P9-BXZ-348

# Camelot at Dawn

Jacqueline and John Kennedy in Georgetown, May 1954

# Camelot

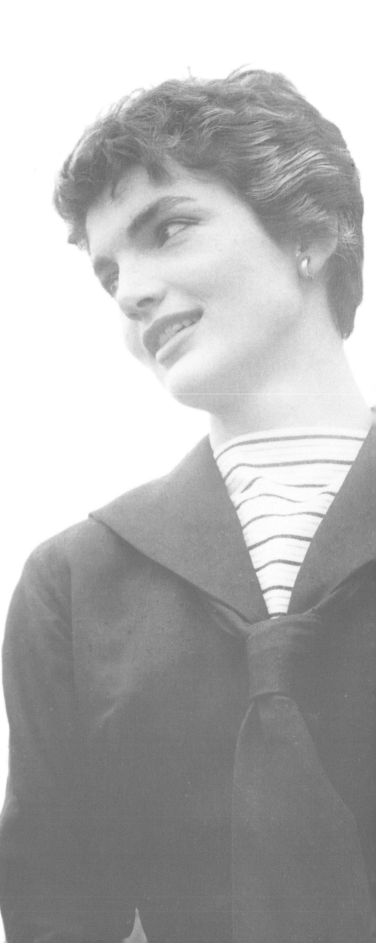

# at Dawn

Photographs by Orlando Suero, text by Anne Garside

The Johns Hopkins University Press : Baltimore and London

© 2001 The Johns Hopkins University Press
All rights reserved. Published 2001
Printed in Italy on acid-free paper
9 8 7 6 5 4 3 2 1

The Johns Hopkins University Press
2715 North Charles Street
Baltimore, Maryland 21218-4363
www.press.jhu.edu

Designed by Glen Burris, set by the designer in Bailey Sans
and Fairfield, and separated and printed on 150 gsm Gardamatt
by Arti Grafiche Amilcare Pizzi, Milan.

Library of Congress Cataloging-in-Publication Data

Suero, Orlando
Camelot at dawn: Jacqueline and John Kennedy in Georgetown, May
1954 /photographs by Orlando Suero; text by Anne Garside.
    p.    cm.
    Includes bibliographical references.
    ISBN 0-8018-6856-4 (alk. paper)
    1. Kennedy, John F. (John Fitzgerald), 1917–1963—Pictorial works.
2. Onassis, Jacqueline Kennedy, 1929–  —Pictorial works. 3. Married
people—United States—Pictorial works. 4. Legislators—United
States—Pictorial works. 5. Legislators' spouses—United States—
Pictorial works. 6. Washington (D.C.)—Social life and customs—
1951—Pictorial works. 7. Kennedy, John F. (John Fitzgerald), 1917–1963.
8. Onassis, Jacqueline Kennedy, 1929–  . 9. Married people—United
States—Biography. 10. Washington (D.C.)—Social life and customs—
1951– I. Garside, Anne. II. Title.
    E842.1 .S84 2001
    973.922'092'2—dc21

2001002305

A catalog record for this book is available from the British Library.

All photographs in this book are from Orlando Suero's collection,
with the exception of the photo on page 13, which was taken by James
Lightner.

## Dedication

This collection of photographs of John and Jacqueline Kennedy was donated to the Peabody Institute of the Johns Hopkins University by Max G. Lowenherz, who was the owner of the Three Lions Picture Agency in New York.

A German-Jewish immigrant, Lowenherz founded the agency in 1937. "Three Lions" was a play on his own name, which means "lionheart" in German, and a reference to his being one of three brothers—Heinz, Walter, and Max—the sons of a cultivated businessman living in Coburg, where Max was born in 1909. In 1933, when the Nazis arrested all the Jews in Coburg, Max was one of only a very few released. He and his brother Walter joined Heinz, who had started a picture agency in Amsterdam.

In 1937 Max arrived in New York, where he established his Three Lions Picture Agency in midtown Manhattan. Walter came over to work with him, but, tragically, Heinz decided to remain in Amsterdam. When the Nazis overran Holland, Heinz and his wife and son were transported to Germany and perished in the Holocaust.

In New York after the war, Max Lowenherz became a notable collector of autographs, but it was Three Lions staff photographer Orlando Suero who produced Max's most cherished collection of memo-rabilia, when Suero documented the life of Senator John F. Kennedy and his new wife, Jacqueline, over one week in May 1954. When Lowenherz sold the Three Lions Picture Agency in 1983, he retained ownership of this remarkable collection. The photographs and negatives remained in his Greenwich Village apartment until 1989, when he decided to give the collection to the Peabody Institute for safekeeping.

The Orlando Suero photographs now reside in the Peabody Archives in Baltimore as "The Max G. Lowenherz Collection of Photographs of John and Jacqueline Kennedy." Max Lowenherz requested that the following statement should accompany his gift:

*Let this visual record of a great American family be my tribute of gratitude to America, which gave me so much.*

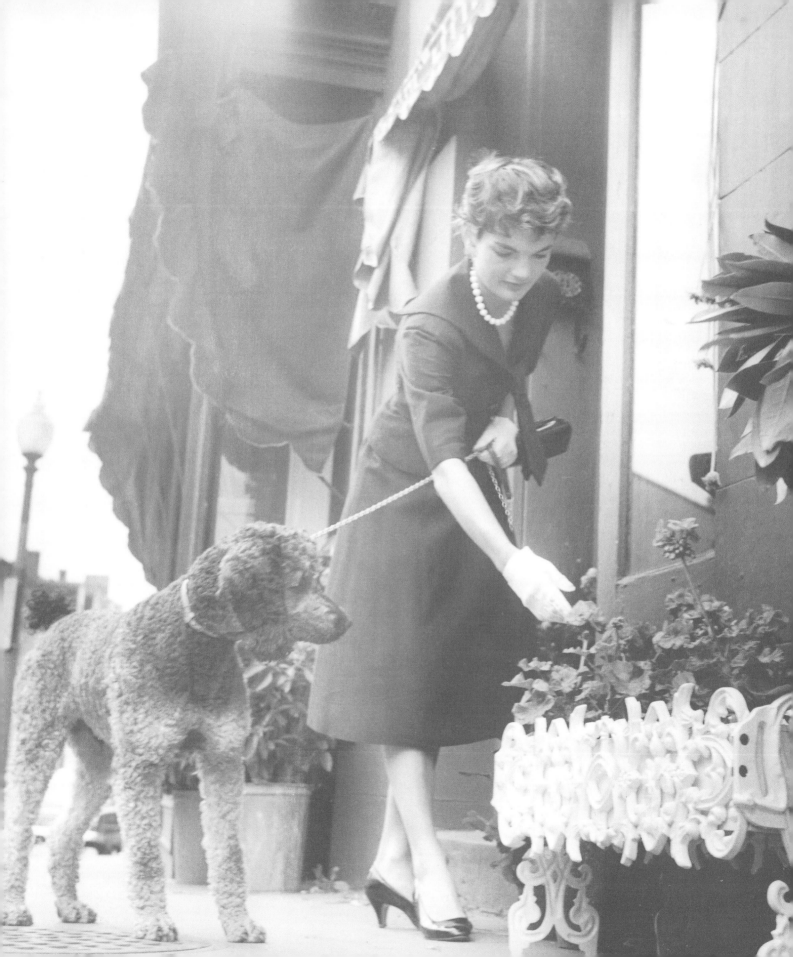

**Contents**

Acknowledgments : ix

Prelude : 1

May 5 to 9, 1954 : 19

Postlude : 85

Sources and Select Bibliography : 95

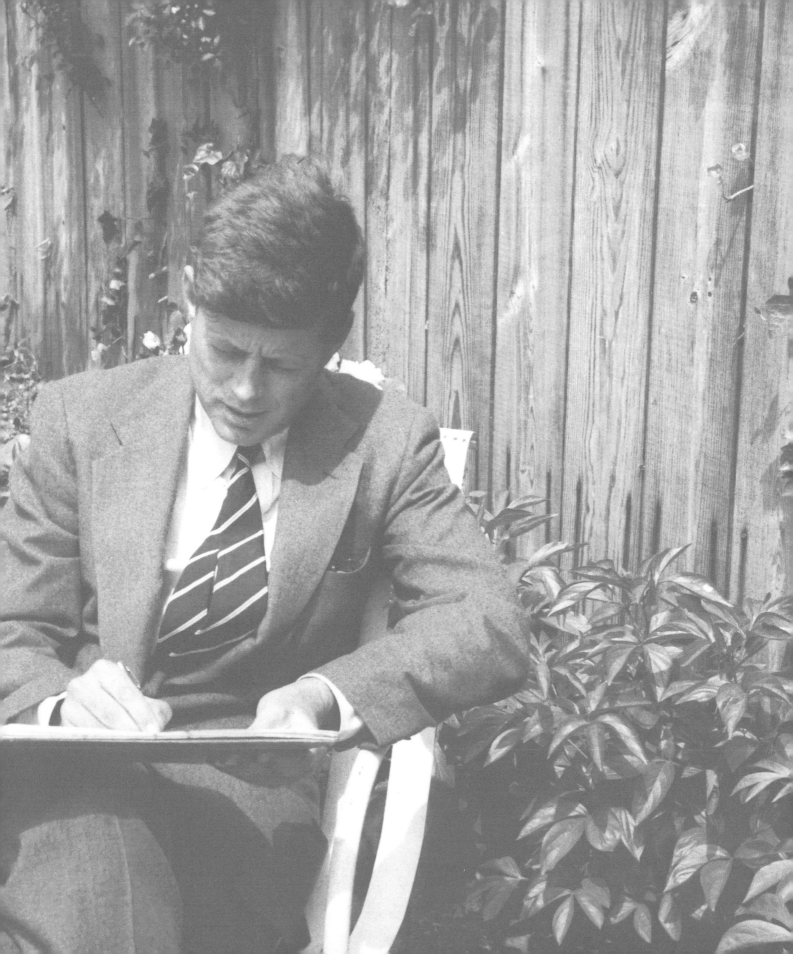

I am deeply grateful to Max G. Lowenherz for entrusting this precious collection of photographs of John and Jacqueline Kennedy to the Peabody Institute of the Johns Hopkins University. I thank him for his friendship and for many delightful visits to his Greenwich Village apartment over the past twelve years.

Without Orlando Suero's beautiful photographs, there would, of course, be no book. Orlando has been most generous in sharing with me his recollections of the time he spent with the Kennedys. He has often said that he regards these photographs as his own "footprints in the sands" of history. They are "footprints" of extraordinary quality.

The late Mrs. Evelyn Lincoln, who visited Peabody in December 1990, helped document the collection and provided invaluable reminiscences for our guidance. It was a thrill to have the assistance of one who had been so close to John F. Kennedy.

The family of Blair and Virginia Childs—their son Blair Childs Jr. and grandchildren S. Terry Childs, Blair G. Childs, and Christopher A. Childs—made an enormous original contribution to this book by providing copies of hitherto unpublished documents pertaining to the lease of Dent Place and the ensuing claims for damages, as well as copies of correspondence that passed between Mattie Penn and the Kennedys. They also shared wonderful anecdotes with me. Terry Childs gave me a personal tour of the house at Dent Place and kindly allowed me to photograph the house as it is today. The Childs family also took the time to check my text to ensure accuracy in the sections pertaining to them.

The John F. Kennedy Library and Museum in Boston supplied a copy of Evelyn Lincoln's office calendar for the first two weeks of May 1954. Curators at the library were responsive to my many questions, in particular Senior Archivist and Curator of Photographs Allan B. Goodrich, Reference Archivist Stephen Plotkin, and Curator of Objects Frank Rigg. It was a great pleasure talking with them, and I thank them for their cooperation.

The Truman Presidential Museum and Library in Independence, Missouri, assisted with the section relating to the Truman seventieth birthday celebration in Washington, D.C.

At the Peabody Institute, I am indebted to two directors, Robert Pierce and Robert Sirota, for allowing me the creative freedom to research and publish this collection. Two Peabody development directors, Thomas E. Holland Jr. and Valerie

Wilson, made the first contacts with Max Lowen-herz. I am especially indebted to Valerie for labor-ing with me through one long, hot August day in an un-air-conditioned warehouse in New York to search out Max's files on the collection. Peabody Archivist Elizabeth Schaaf, who is in herself a treasured resource, has provided enormous sup-port in the preservation and cataloging of the photographs. Christine Kloostra and Nan Sommers, my assistants in the Peabody Public Information Office, have borne with me patiently during the many weeks that my mind has been preoccupied with the Kennedys.

I am indebted to Frederick T. DeKuyper, former associate legal counsel of the Johns Hopkins Univer-sity, who meticulously verified the chain of custody and ownership in the collection.

Steven Muller, president emeritus of the Johns Hopkins University, who guided me through the terminology of ball games (*not* my field of exper-tise), and his wife, Jill McGovern Muller, have provided warm encouragement and help. I deeply cherish our friendship.

Ross Jones, former vice president and secretary of the Johns Hopkins University, who has been a most congenial colleague and friend of many years' standing, kindly researched the details of the speed-reading class that JFK and RFK took in the Hopkins Evening College.

Most of all, this book would not have been writ-ten without the incentive provided by the Friends of Peabody Steering Committee, chaired by Wendy Brody, wife of William R. Brody, president of the Johns Hopkins University. Her enthusiasm has led

to the scheduling of an exhibition of the Kennedy photographs in spring 2002, at Evergreen House in Baltimore. Filled with art treasures and the site of the famous Bakst Theater, this historic mansion on North Charles Street was the home of two genera-tions of Garretts and now belongs to the university. The director of Evergreen House, Cindy Kelly, has shown equal enthusiasm for the project. Although this book has grown far beyond an exhibition cata-log, it owes its publication to the incentive provided by this forthcoming exhibition.

I am grateful to Lt. Gov. Kathleen Kennedy Townsend for her gracious consent to serve as honorary chair for the exhibition, and I would also like to thank the lieutenant governor and her mother, Mrs. Robert F. Kennedy, for their support of a first modest exhibition of the collection held at Peabody in 1990.

At the Johns Hopkins University Press, Re-gional Books Editor Robert J. Brugger has helped shape the manuscript and has provided encour-agement and advice. Managing Editor Barbara B. Lamb offered editing help before and after turn-ing the manuscript over to Lois R. Crum, who expeditiously completed the editing. The imagina-tive layout is the work of Glen Burris. Responsi-bility for the editorial content is, of course, solely my own.

The prints for the reproductions in this book have been skillfully hand processed by Lightner Photogra-phy, Inc., Baltimore.

Finally, I would like to note that because these marvelous photographs have been in my conscious-ness for so many years, I have developed a real

empathy for the subjects that no doubt has seeped into my text. This is in no way an "investigative" book. I have simply tried to provide as much factual background as seems necessary to understand what the photographs represent. However much has been written about the Kennedys, the fascination endures.

ANNE GARSIDE
April 2001

# Prelude

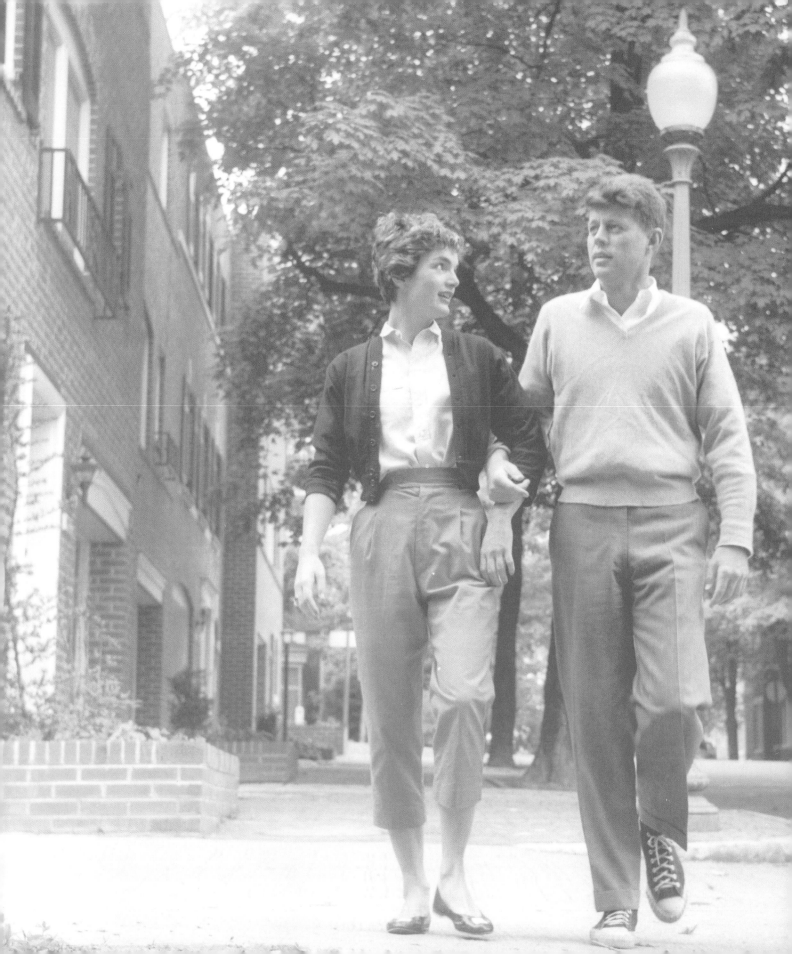

Senator John Fitzgerald Kennedy married Jacqueline Lee Bouvier in Newport, Rhode Island, on September 12, 1953. It was the society wedding of the year. Photographs of the glamorous bride and groom appeared in newspapers and magazines across the country. Because Jack looked so boyish, the wedding guests thought of them as a young couple, but the difference in age was actually considerable. Jack Kennedy was thirty-six, his bride twenty-four.

The media coverage had been orchestrated by Jack's father, "the Ambassador." Joseph Kennedy Sr. had early seen the potential of the new age of mass media. He knew that the media could create celebrity and was determined that his son would use celebrity to gain the presidency of the United States.

Originally it had been the ambassador's eldest son, Joseph Kennedy Jr., who was expected to fulfill his father's political ambitions. When Joe Junior died in a plane crash in World War II, the ambassador transferred these ambitions to his second son. It seemed an improbable choice at the time. As a child and young adult, Jack suffered so many life-threatening illnesses that younger brother Bobby joked that if a mosquito bit Jack, the mosquito would die. Nonetheless, in 1946 Jack Kennedy

was elected to Congress from the state of Massachusetts, and in 1952 he captured a Senate seat.

Kennedy Senior realized early on that Jacqueline Bouvier, with her keen intelligence and aristocratic family background, would provide the ideal wife to further Jack's political career, and he was determined that the wedding would make a big social splash. Jackie's mother, Janet Auchincloss, considered it vulgar to court press attention, but Jack, a true son of his father, had never met a camera he didn't like.

After the wedding, the couple lived for a few months like gypsies. As his legal domicile for his constituency, Jack owned a cramped three-room apartment on Bowdoin Street in downtown Boston. For a while before his marriage, he had shared a house in Georgetown with his sister Eunice. Jack Kennedy didn't see any urgency about buying a home when he and his wife could live at the various properties owned by their respective families. The Kennedys had houses at Hyannis Port and Palm Beach and apartments in New York. Jackie had the Auchincloss properties of her stepfather at her disposal—Hammersmith Farm, where the couple had held their wedding reception, and Merrywood, an estate situated on the Potomac in Virginia.

The newlyweds honeymooned in Acapulco and vacationed in California; they spent Thanksgiving at Hyannis Port and Christmas at Palm Beach. That fall Jackie stayed at Hyannis Port during the week, with Jack joining her only on weekends. These prolonged stays with her in-laws made her anxious to find a place of their own. Jack insisted it be in Georgetown so that he could be close to his brother Bobby, who, at the age of twenty-six, had managed JFK's 1952 election campaign for the Senate. Jackie spent days hunting for a suitable house to rent until they found one to buy.

By December 1953, they had discovered a typically narrow, three-story townhouse at 3321 Dent Place in Georgetown. Jack's personal secretary, Evelyn Lincoln, arranged for them to rent it, furnished, for six months. The couple took up residence in early January 1954 and, like any other newlyweds, began adjusting to married life together. Their stay in the house at Dent Place has received only passing mention in books about the Kennedys. Yet these few months in their first home were perhaps the only relatively normal time in Jack and Jackie's married life.

Jack was already aiming for higher office. In the early months of 1954, in an attempt to gain greater national recognition, he had deliberately begun speaking out on national and international issues that ran far beyond the interests of his own constituents in Massachusetts. Kennedy's new aide, Ted Sorensen, who had joined his office in January 1953, kept up a steady stream of articles over the senator's signature in such national magazines as the *New Republic,* the *New York Times Magazine,* and the *Atlantic Monthly,* actively courting press attention for his boss. But the press mostly regarded Jack Kennedy as a very junior and lightweight senator, one who had gained his seat largely because of his millionaire father's money. Kennedy was ready to grasp at any publicity that showed him as a serious, hard-working political figure.

Happily, in April 1954, Max Lowenherz's Three Lions Picture Agency in New York held a routine staff meeting to discuss upcoming photo assignments for staff photographer Orlando Suero. Then age twenty-nine, Suero (later to become a notable photojournalist and then a Hollywood still photographer) suggested that he do a photo-essay on the Kennedys, whose wedding the previous September had generated such enormous publicity. He managed to secure a provisional commitment from *McCall's* magazine to run some of the photographs as a "woman's interest" story on how the newlywed Jacqueline Kennedy was keeping up with her husband's political activities.

When Suero telephoned Kennedy's office to request permission for the photo shoot, the senator welcomed the idea. So Suero drove down U.S. 1 to Georgetown and spent about five days, from May 4 to May 9, with John and Jacqueline Kennedy. He enjoyed the Kennedys' full cooperation and the intimate access that later they denied to all but a carefully chosen handful of photographers, as Jacqueline became more and more anxious to guard her own and her children's privacy. In twenty-some separate photo sessions during his brief stay in Washington, Suero produced more than a thousand negatives of the Kennedys. He was the only person to do an extensive photo-documentary on the couple that year.

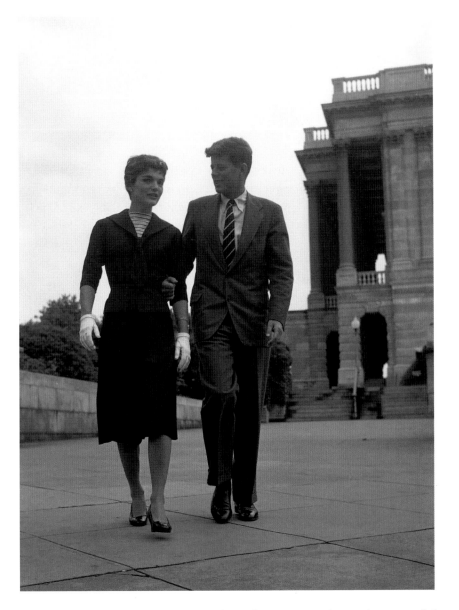

Of course Suero did not exercise unlimited creative freedom; the sessions reflected the image that the Kennedys themselves wished to project. Suero's camera captured them as a glamorous couple who appeared to have everything one could wish for—youth, good looks, money, social position, and political power. In one tell-tale sequence, they stand handsomely against a backdrop of the United States Capitol itself. They appear to be striding into the future together, full of confidence. The fact that Suero carried out his assignment in the spring—Washington's season of cherry blossoms—helped to foster the illusion.

In reality, John and Jacqueline at that time were experiencing many difficulties adjusting to one another. Jack thought he could continue living as though still a bachelor. He liked to fill the house with guests, whereas Jackie preferred a more private life. Jack traveled much of the time, leaving Jackie alone.

Moreover, Jackie was becoming fully aware that she had married a man who could become perma-

nently crippled and might end up in a wheelchair. Jack suffered severe back pain and faced the uncertain outcome of surgery to alleviate it. The family tried to give Jack's problems a heroic cast. They ascribed them to a football injury he had suffered at Harvard, made worse when a Japanese destroyer rammed the torpedo boat he skippered in the Pacific Theater of the recent war. Later in May 1954, the senator used crutches all the time, hiding them if anyone entered his office. Jack knew that the double spinal-fusion operation, advocated by some doctors as a solution to his chronic pain, was especially dangerous because he had Addison's disease, which lowered his immunity to infection.

Because his future was so uncertain, Jack and Jackie postponed their hunt for a house to buy. The Kennedys gave up their lease on Dent Place in June. For the rest of that summer, they resumed their nomadic lifestyle, living with their in-laws. Jackie remained at Merrywood most of the time. Jack finally had the operation in October, nearly died from the resulting infection, and had to have a second operation in February of the following year. The young senator dropped out of public life from the fall of 1954 until late spring 1955, while he recuperated at his parents' house in Palm Beach.

Suero could not know it at the time, but his camera was recording the couple in just about the last window of opportunity in which Jack and Jackie could appear as happy newlyweds. It was also a period when they were not dogged by incessant press attention. In spite of various underlying tensions, Suero's photographs project an idyllic quality, capturing a time of comparative inno-

cence. His camera recorded the pair looking at their wedding photos together, working in Jack's Senate office, tossing a football with near neighbors Bobby and Ethel Kennedy, attending a reception in honor of former president Harry Truman, and relaxing in the small backyard garden at Dent Place. For a few weekends Jack tried his hand at painting in oils. Jackie took a class at Georgetown University. When she held her first formal dinner party, Suero caught the magical image of her lighting candles on the table.

Today it is hard to view these photographs without projecting onto them our knowledge of the dramatic events that lay in store. The discerning eye of Suero's camera seems to portray this young couple as strangely vulnerable. This "time capsule" of Jack and Jackie's early married life gives us a glimpse of Camelot at dawn.

John F. Kennedy's personal secretary, Evelyn Lincoln, kept an office calendar that proves invaluable in dating and researching Orlando Suero's photographs. Mrs. Lincoln, who worked for JFK from 1952 until his assassination on November 22, 1963, used the calendar as her personal desk diary. The entries are sometimes cryptic, but they do provide a chronological framework for the first two weeks in May 1954.

A week or so before Suero brought his camera into their lives, the Kennedys had been in New York, attending the April 24 wedding of Jack's sister Patricia to the Hollywood actor Peter Lawford. The calendar indicates that the senator then went to Los Angeles, returning to Washington on Tuesday, May 4, the day Orlando Suero arrived in town.

As Mrs. Lincoln also kept track of Jacqueline Kennedy's official engagements, the secretary has written into the calendar a photo shoot for Jackie at Georgetown University on May 5. The same day, at 3 P.M., Jack had a tape recording at the Capitol, apparently for a press interview on Indochina, the topic of a major speech he had delivered a few weeks earlier.

For the evening of May 5, the secretary noted a dinner for the Civil Air Patrol at the Shoreham Hotel and wrote, "Try to stop by before dinner," with the names "Charles Bartlett, Mansfield, Warren and White" bracketed below. Bartlett, a newspaperman with the *Chattanooga Times,* was a longtime personal friend of JFK and had introduced Jack and Jackie at a dinner party at his home. "Mansfield" presumably refers to Senator Mike Mansfield, a JFK ally. "Warren" may be the Earl Warren who later, as chief justice of the United States, administered the oath of office to JFK and subsequently headed the commission that investigated his assassination. The identity of "White" is not known.

Mrs. Lincoln has noted that, from May 6 to 9, Suero would be carrying out photo shoots with the senator for the October issue of *McCall's* magazine. The photo sessions in Jack's Senate office took place on the morning of Thursday, May 6, squeezed in between JFK's appointments. For that evening, the calendar records the Democratic Party's annual Jefferson-Jackson Day Dinner at the Mayflower Hotel.

Although, surprisingly, the event did not make Mrs. Lincoln's desk calendar, we know that John and Jacqueline Kennedy put in an appearance at a reception celebrating Harry Truman's seventieth

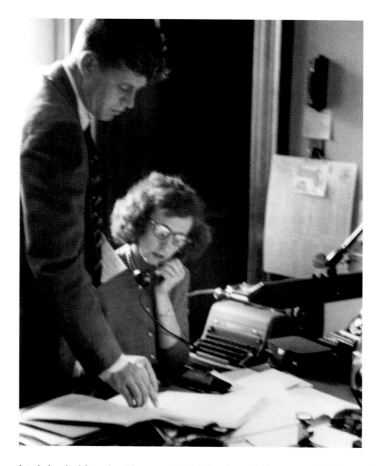

birthday held at the Sheraton Park Hotel on Friday, May 7, from 5 to 7 P.M. Suero snapped them talking with the entire Truman family at this affair.

Jackie's first formal dinner party at Dent Place, at which the photographer captured a magical (and now celebrated) shot of her lighting candles, took place after the Truman reception on the evening of May 7. Because this was a private party, there is no office record of it, so we do not know who all the guests were.

On Saturday afternoon, May 8, Suero took shots of Jack and Jackie and Bobby and Ethel tossing a ball around in the small neighborhood park just a block away from the house at Dent Place. Neither the ballgame in the park nor Suero's visit (presumably that weekend) to Bobby and Ethel's home appears in the office desk diary.

Bobby and Ethel are also shown dining informally with Jack and Jackie during this period in May. Since the candles on the table are lit, it must have been an evening party. Tuesday, May 4, appears to be the only available date for this gathering, although Mrs. Lincoln's calendar has an engagement, "Dinner with Sherlings prior to Home Rule Bill," for that night. Possibly the Kennedys declined the dinner or left early to have coffee and dessert at home.

On Saturday, May 8, the only formal engagements noted in the office calendar are for a "Joe Alsop Dinner" beginning at 8 P.M. and a "Small Dance at River's End" afterward. Joseph Alsop, a syndicated newspaper columnist, was assiduously cultivated by the Kennedys. There is no indication of the significance of the "Small Dance at River's End," but this appears to be the occasion when

Jackie floats down the stairs in a crinoline dance dress to Jack's admiring gaze.

On Sunday, May 9, Suero captured Jack painting in oils in the backyard at Dent Place. The engagement calendar is left blank until 4:00–4:30 P.M. that day, when JFK was interviewed on a local *Man of the Week* television program, followed by "Metro Club Dinner." The last entry refers to Washington's swank Metropolitan Club.

Orlando Suero remained in Washington through Sunday night and left sometime on Monday. JFK also left Washington on May 10, taking a lunchtime plane to New York. Among his other engagements in New York, Mrs. Lincoln has scribbled in a meeting with Francis Cardinal Spellman, a close family friend of the Kennedys.

Although the photographer was not there to record these subsequent engagements, it is interesting to note that on Tuesday, May 11, Jackie was to have lunch with former first lady Eleanor Roosevelt. On Wednesday, the senator, back from New York, made a speech at the Johns Hopkins School of Advanced International Studies in Washington. The next day, both Kennedys were scheduled to lunch at the White House (the calendar gave no details as to the occasion).

On Thursday, May 13, the calendar also noted a 7:30 A.M. Mass at St. Thomas Apostles Church, with the name Kathleen written beside it. May 13, 1948, was the day Jack lost his favorite sister, Kathleen Kennedy—"Kick," as she was always called. Kick Kennedy had married Lord William Hartington, eldest son of the Duke of Devonshire, on May 6, 1944. Because Hartington was a Protestant,

the ceremony was performed, much to Rose Kennedy's horror, in the Chelsea Registry Office in London. The young couple only managed to have five weeks of married life together; Hartington, an officer in the Coldstream Guards, was posted to France and subsequently killed in Belgium in September 1944. Four years later, Kick was killed, at the age of twenty-eight, in a plane crash in the French Alps. Evidently, Jack planned to attend mass that day in her memory.

The entries clearly indicate the hectic pace of John F. Kennedy's work and travel schedule and demonstrate the demands it placed on Jacqueline as a Senate wife—all of which added to the strains in their early married life.

Today the house at 3321 Dent Place stands virtually unchanged since the period when the Kennedys rented it from Blair Childs and his wife, Virginia Fiske Childs. The Childses, who were friends of the Auchincloss family, let the couple have the place for $395 a month for six months, from December 15, 1953, to June 14, 1954. A provision in the lease granted the Kennedys the privilege of renewing the lease for an additional month if Congress remained in session.

The Childses were leaving for a six-month holiday in Europe and were glad to find a tenant—even if he was a Democrat. The Childs family was staunchly Republican; one relative by marriage, Meade Alcorn, was later to serve as chairman of the Republican National Committee during the Eisenhower administration. Blair and Virginia Childs owned a country house close to Merrywood, the estate belonging to Jackie's stepfather. Thus the Childses' son, Blair Childs Jr., was a great friend of Jackie's stepbrother, Yusha Auchincloss, and he and Jackie had frequently attended the same coming-out parties.

One-half of a duplex, the house at Dent Place is a typically modest Georgetown residence, only fourteen feet wide by fifty feet deep, consisting of three stories that include a dining room and kitchen on the first floor, a second-floor living room and study,

two bedrooms on the third floor, and a basement. Although 19th-century in style, it was actually built in the 1940s. Behind the house is a narrow, patio-style yard paved in red brick. It is enclosed on each side by a high wooden fence and sealed off at the end by a red brick garage, making a delightfully secluded spot.

The Childs family still owns the originals of the lease signed by all four parties—both wives and husbands—and of the correspondence that followed the Kennedys' moving out. Before Jack and Jackie took possession, a professional Washington company, Household Inventories, had drawn up a list of the furnishings. The same firm checked the list when the young couple vacated the house and reported to Mrs. Childs in a letter dated June 22 a long catalog of minor damages and missing household items.

"Mrs. Kennedy agreed to have everything back in place at the time of check-out," the firm complained, "and such was not the case. Books have been left in the garage, rugs & linen stored and all the silver is badly tarnished. These items should have been replaced to the position shown in the inventory and the silver should have been left in the condition it was found, whether or not the

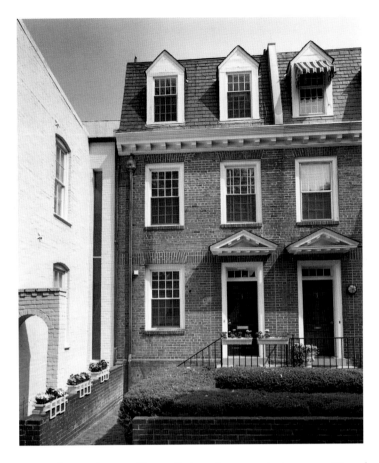

Kennedys used it. . . . The walls have been marked on the stairways, by furniture being moved and additional holes have been made in the walls to hang pictures."

A week later, another letter from Household Inventories reported that Mrs. Kennedy had found some of the missing household items but that the following things remained unaccounted for:

1. Aluminum tray with pheasant
2. 2 down pillows and zippered covers
3. Original "gouache" in gold frame
4. 1 frying pan

The letter goes on to say that "the bedroom rods have been removed, as well as the brass hooks in the front bedroom closets. The yellow chair in the den needs repairing as the springs are broken. There is a broken window in the back bedroom and a handle off the Victrola. [The Kennedys had their own Victrola, so had stored the Childs' machine in the garage, hence the broken handle.] The Italian mirror that was missing is now there but the center panel has been badly cracked. Whether an artisan can be found, around Washington, who can reproduce this panel, is rather doubtful."

The next letter in the sequence, from Virginia Childs to Household Inventories, itemized the cost of repairs and replacement of missing items and drew attention to the fact that Jackie had painted the bedroom furniture black! Mrs. Childs had agreed to Jackie's painting the furniture, but the agreement had specified green. Presumably Jackie had the furniture repainted, because today the Childses' son, Blair Childs Jr., remembers from his childhood the furniture being "a quite bilious green!" Mrs. Childs did make some concessions: "I am not asking for replacement of the shade (#13) which is torn and soiled; the repair on folding desk

(#20); and the shag rug in the bathroom (#23)," which she generously offers, "I will have cleaned at my own expense." Nonetheless, there were some things that she hoped Mrs. Kennedy would still find:

> Aluminum place [*sic*] with pheasant (#6) $15.00
> 2 down pillows, Hecht-7th St., $18.95 each
> 2 cotton zip cases $0.79
> Frying pan $3.50

Mrs. Childs ends by saying plaintively: "My gouache painting in my bedroom is difficult to put a value on, and I sincerely hope it is returned. . . . Would you kindly have this settled at once, as I am leaving for California." She enclosed a list of the damages and missing items with dollar amounts spelled out in detail.

The next stage in the negotiations was a letter from Jackie:

> Dear Mrs. Childs—
>
> The original total of what I owed you was $378.61. I subtract $1.65 for the three hooks we found and $6.40 for the curtain rod brackets— which left it at $370.49. Then I added $15 for the pheasant plate—Grand total $385.49!
> Have a wonderful trip to California.
>
> Love,
> Jackie

Jackie made a mistake in the arithmetic—the grand total should have been $385.56—but Mrs. Childs may have been beyond further dispute with the penurious Kennedys. Jackie's missive seems to

have settled the matter, except for a terse handwritten note from Jack on Merrywood letterhead enclosing the check.

There remains to this day one final reminder of Jack and Jackie's stay at 3321 Dent Place. In clearing out some closets, Terry Childs, granddaughter of Blair and Virginia, discovered two wooden hangers, each one stamped "John F. Kennedy." The hangers probably date from Jack's Choate Preparatory School days, when all his belongings had to be marked with his name. If Jack and Jackie had known these pants hangers had been left behind in the house, one wonders whether their value would have been deducted from the final settlement with the Childses.

JFK's casual attitude toward his own and other people's belongings was proverbial. His Harvard roommate Torby McDonald once complained that Jack "threw his clothes in heaps around the room making the place look like a rummage sale." Doubtless many of the claims for the items the Childses found missing can be ascribed to Jack's untidiness. As for Jackie, throughout her entire life, she compulsively redecorated every house she ever lived in, including the White House, sometimes several times over.

The house at Dent Place was only one of many Georgetown residences that John and Jacqueline Kennedy occupied, either separately or together. Indeed, for years, their lives seemed to revolve in concentric circles around a few blocks of this trendy Washington neighborhood. Jack and Jackie's mutual friend Charlie Bartlett lived at 3419 Q Street. Before his marriage, Jack had shared a house with his sister

Eunice on Thirty-first Street. Then came 3321 Dent Place. Bobby and Ethel lived nearby, first on S and then on O Street. In the late spring of 1955, after Jack recovered from his back surgery and the Kennedys returned to Washington, they purchased Hickory Hill, in McLean, Virginia. But when her first child was born dead, Jackie could not bear the sight of the nursery she had set up for the baby. Jack sold Hickory Hill to Bobby and Ethel and bought the house at 3307 N Street—their most famous address because it was their home when Jack ran for president.

After JFK's assassination, his widow would move temporarily into Averell Harriman's home at 3036 N Street before buying a house across the way at 3017. It probably seemed natural to Jacqueline Kennedy to seek refuge in the old Georgetown neighborhood that held so many memories of Jack. Sadly, after only a short stay in her new home, crowds of curious sightseers drove her to an apartment on Park Avenue in New York. Interior decorator Elisabeth Draper, who advised Jackie on the house at 3307 N Street, later remarked that she "felt badly for Jackie—she and Jack had moved from house to house. It gave their marriage a kind of temporary quality, a sense of 'nothing is permanent.' I don't know how to say it exactly—every home she had ever lived in was like a one-night stand."

Jack's old wartime buddy, Red Fay, who became undersecretary of the navy after Kennedy became president, recounts that on Sunday, January 22, two days after the inauguration, Jack invited Fay to accompany him to Mass. On their way, Kennedy asked the driver to take him past his old home on N Street. To his annoyance he saw that, in spite of orders to cancel all deliveries, the front steps were piled with newspapers. He ordered the driver to stop the car, and the new president of the United States jumped out and set about clearing the steps, pitching the newspapers into the limousine. Perhaps JFK remembered the haggling over the state in which he had left the house at Dent Place and did not want his N Street neighbors to have any cause for complaint. But other habits hadn't changed. When they got to the church and it came time to take the collection, the president, as usual, had no cash on his person. He leaned over to Fay and whispered, "Slip me at least a ten. I want them to know this is a generous president."

When Suero arrived at Dent Place, late Tuesday afternoon, he tried to put Jackie at ease before taking out his camera. "I sat and talked with her," he remembers, "and explained what I wanted to do. I wanted her to get used to me first, so I left my camera in the car. In the 1950s, the style for photography was very straightforward, not at all avant-garde. *McCall's* just wanted straightforward photos. There was nothing 'investigative' about the assignment."

At their first meeting, as housekeeper Mattie Penn served tea and coffee, Jackie asked Orlando about himself. Suero, who had been born in New York into a Spanish-American family, was, at twenty-nine, only a few years older than she; the nearness in their ages also contributed to a feeling of ease. The senator came in about an hour or so later and joined in the talk: "I didn't phony up anything about myself or my abilities," explains Suero. "I told them very frankly that this was my first big assignment. They seemed to like my honesty and I believe it helped build up the rapport between us so that I had the freedom to do the story. It also worked the other way. I wasn't in awe of these people because *they* had put *me* so much at ease."

The photographer had some experiences in common with Kennedy, since they had both served in the war in the Pacific. In 1943 Orlando had joined the U.S. Marine Corps and fought in the Marshall Islands, the Mariannas (where he was wounded on Guam), and in the final battle for Okinawa. JFK, of course, had been the skipper of the famous PT-109 boat patrolling the Solomon Islands.

Although Suero had embarked on a "woman's interest" story, he found that as he worked on the assignment, "John Kennedy kept sneaking himself into the pictures." The assignment produced as much photo-documentary material on JFK as on his new wife.

In his subsequent career as a freelance photo-journalist, Suero continued to use Orlando as his professional name. His work appeared in major magazines all over the world, including *Time, Life, Look, Saturday Evening Post, Paris Match,* and *Stern.* His photographs were released through the Globe Photos agency. For a while Suero was one of the photographers who had press credentials to cover the United Nations. He found himself doing photo-essays on world leaders, from United Nations Secretary-General Dag Hammarskjöld to Cuba's Fidel Castro. He himself likes to character-

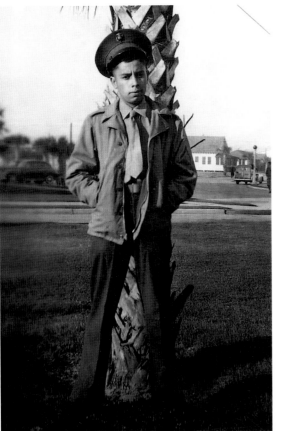

Orlando Suero as a young
Marine on Parris Island.

ize this part of his career as his "Hemingway period." The "Hemingway" years evoke Suero's sense of nostalgia for what he calls "the days of the trench-coat and two Leicas and off to Vienna! This was the golden age of photojournalism," he points out, "before the advent of television destroyed the market for still photos, and most of the picture magazines folded."

Later still, Suero was to embark on what he calls his "glamour period"— the approximately twenty-eight years when he was a well-known Hollywood still photographer living in Los Angeles. During those years he turned his lens on scores of movie stars—Fred Astaire, Brigitte Bardot, Steve McQueen, Lee Marvin (a Marine Corps buddy), Jeanne Moreau, Robert Taylor, Natalie Wood, and others.

But Suero's 1954 assignment to document the life of a junior senator and his young wife produced the most memorable and historically important photographs of his entire career. In a remarkable shot —a casual shot of them leaning over the balcony of the second-floor living room of the Dent Place house—Jackie's close-cropped hair shows off the widely spaced eyes that make photographs of her so arresting. Jack, clad in a T-shirt, reminds us of the contemporary movie idol James Dean. By the time this photograph was taken on Sunday, May 9, photographer Orlando Suero had already been following the Kennedys around for a few days. Jack and Jackie appear completely relaxed in front of the camera.

May 5 to 9, 1954

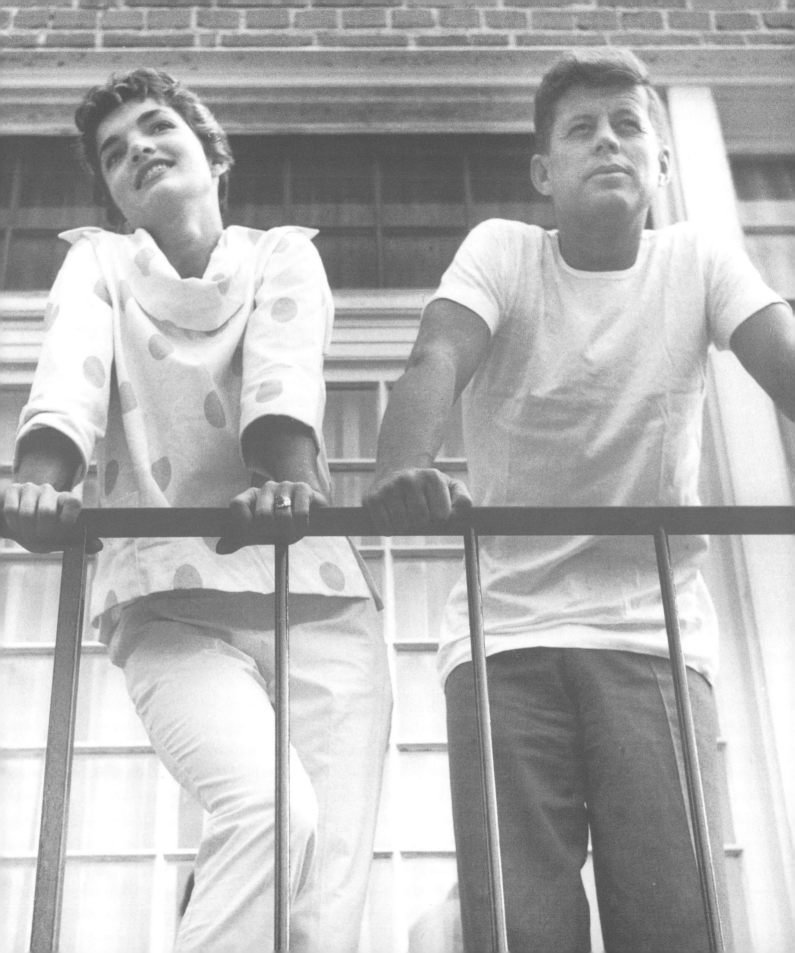

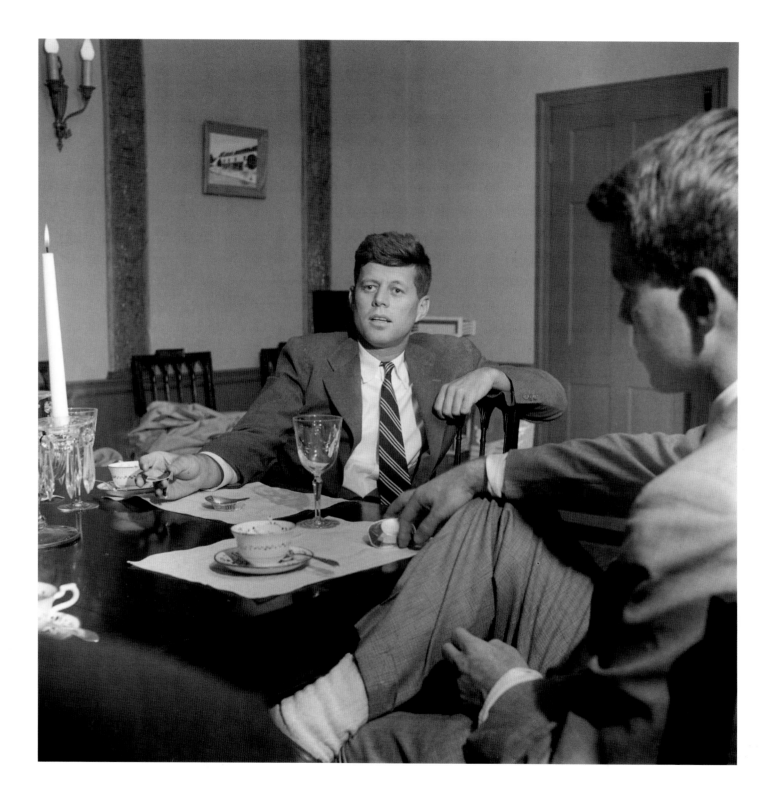

Jack and Jackie much preferred having a few close friends in for dinner to going out to official Washington parties. Orlando Suero was present at an informal dinner party when the guests included Robert and Ethel Kennedy, family friend Lem Billings (the tall man in the white suit), and an unidentified guest. Suero caught the closeness between the two brothers as they sat chatting together, with their chairs half pushed away from the table.

Bobby has brought his German shepherd puppy along and is petting the animal. Of all the dogs RFK had over the years, only two, Brumus the Lab and Freckles the spaniel, became famous—or at least remembered by name. However, this puppy did accompany Bobby and Ethel when they moved to Hickory Hill. House guest Lem Billings also had his big poodle with him, so Jackie had four guests and two dogs for dinner that night. As Jack was allergic to dogs, his varying facial expressions can be interpreted either as fascinated interest in the dinner table conversation or a determination not to sneeze.

After dinner, Jack smoked a Cuban cigar, a taste he had acquired since his wedding. Jackie encouraged it so that he could not complain about her smoking. Later, as president, he had to renounce Cuban cigars when the United States imposed a blockade on Cuba.

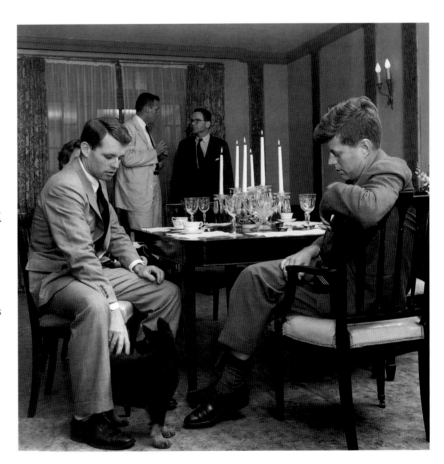

Jack was born May 29, 1917; Bobby November 20, 1925. While Bobby was growing up, Jack was away at school and college, and then in the navy. With a more than eight-year age difference between them, it wasn't until the early 1950s that the two started becoming really close. In 1952, at the age of twenty-six, Bobby put in a loyal and ferocious stint as campaign manager for Jack's bid for the Senate. Over the next eleven years, the relationship between the two brothers was one of such total commitment that some Kennedy historians even speak of a co-presidency.

Although the house at Dent Place was rented furnished, Jackie had brought her own silver and Sèvres china with her. Jackie was a silver-and-Sèvres kind of girl, whereas Jack was a milk shake–and–hamburger kind of guy. Before his marriage, when Jack was sharing a house on Thirty-first Street in Georgetown with his sister Eunice, guests frequently found half-eaten hamburgers tucked behind picture frames, and the rooms often looked like a fraternity house after a party weekend. Jackie, in contrast, had grown up with a mother who insisted on the social graces. Even at this small informal dinner party, she has set the table with simple elegance.

The relaxed pose of the two brothers gives no indication that at the time Bobby was fiercely embroiled in the U.S. Senate hearings attacking Senator Joseph McCarthy in the celebrated Army-McCarthy hearings. In this era of exaggerated American phobia about Communism, McCarthy was conducting a witch hunt for suspected Reds.

The hearings had been set up to investigate McCarthy's chief counsel, Roy Cohn. Flagrantly abusing his official position, Cohn had tried to intimidate the army into providing preferential treatment for a homosexual friend of his, a millionaire's playboy son, G. David Schine. Schine had been called up as an ordinary G.I. Cohn wanted the army to appoint his friend to a position where he would be helping Cohn investigate alleged Communist leanings in the army.

The army courageously decided to confront Cohn, and by inference McCarthy, head on. The televised hearings began on April 22 and did not end until June 17, holding an estimated 20 million viewers spellbound. As counsel to the three-member Democratic minority of the McCarthy subcommittee, Robert Kennedy sat behind the three senators and provided them with questions and briefs to

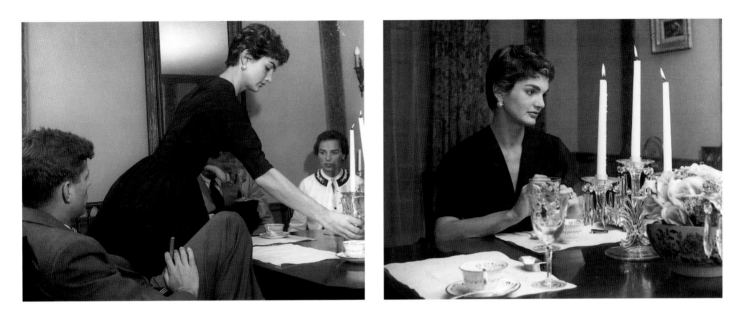

discredit Cohn. Thus RFK became a familiar face to viewers, as did Ethel, who attended the hearings almost every day, sitting in a front-row seat.

The hearings, which were the beginning of the end for McCarthy, marked the emergence of Bobby as a public figure. But they created a dilemma for Jack. It was difficult for him to join in the general censure of McCarthy, who was a close personal friend of the Kennedy family. More importantly, many of Jack's Irish-Catholic constituents totally supported McCarthy in his fight against "godless Communism." Because the hearings were the burning topic of the day, it seems highly probable that Jack and Bobby were discussing them around the dinner table at Dent Place.

Captured through the lens of Suero's camera, Jack's younger brother looks like a kid fresh out of college. The twenty-eight-year-old was, however, already exhibiting the attack qualities of a rott-weiler. In a memo written in March that year, J. Edgar Hoover, director of the FBI, had called Robert Kennedy "a dangerous fellow."

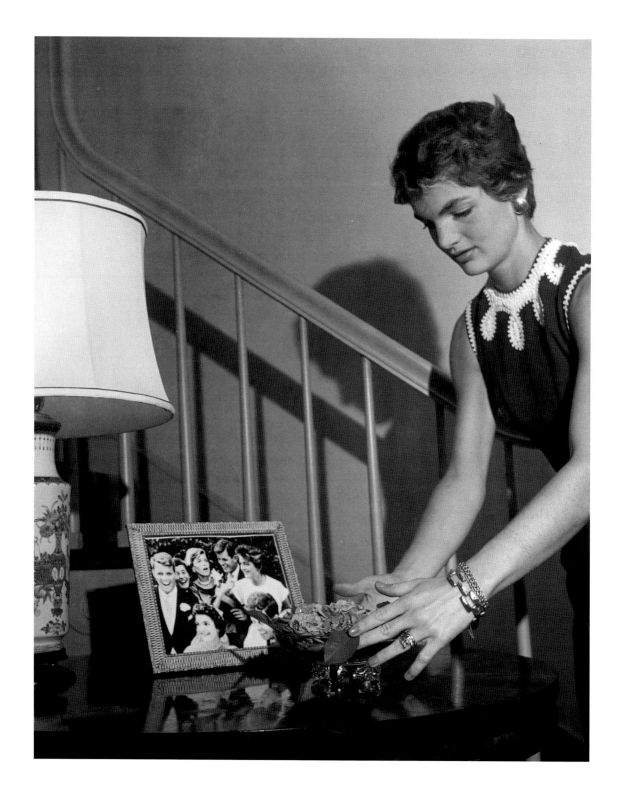

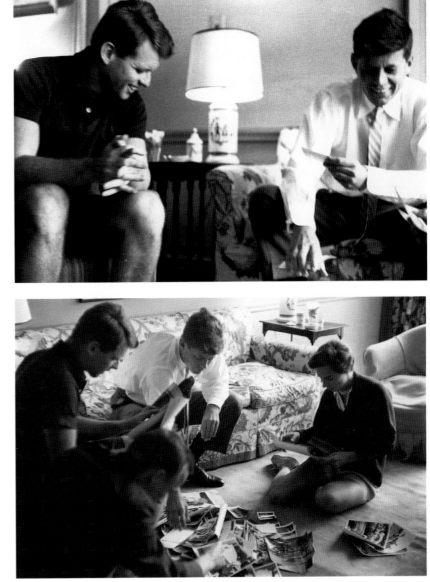

Although Jack and Jackie had been in the Dent Place house since January, when Orlando brought his camera into their lives, they were still engaged in unpacking boxes.

"This day Jack and Jackie were hunting for a particular photo," explains Suero. "Bobby and Ethel were there, too. They pulled out a lot of boxes in the search, and suddenly their wedding photos spilled out of one of the boxes all over the floor, so they all started looking at them." Bobby had been Jack's best man, and Ethel one of Jackie's brides-maids, so the two couples, now near neighbors in Georgetown, spent a happy half hour looking at the photos and reminiscing about the wedding. The photographer remembers "a lot of laughter, and a very gay atmosphere. At that time, it seemed to me," he says, "that Jack and Jackie would both fit in one glove. They seemed very close, very warm and affectionate with each other. What I witnessed seemed to be a very warm and loving relationship."

During another photo session, Suero photo-graphed Jackie proudly placing a bowl of miniature roses that she had grown herself in the garden at Dent Place before one of their framed wedding photos.

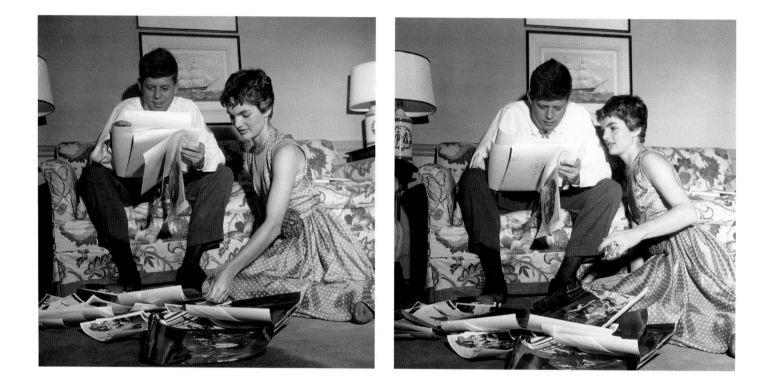

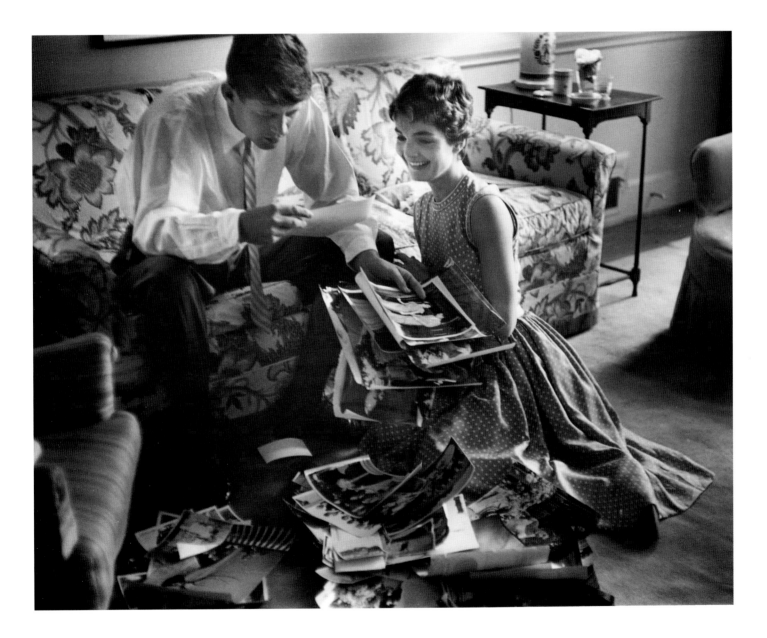

When Suero telephoned Kennedy's office to request permission for his photo assignment, he first spoke with Evelyn Lincoln, the senator's personal secretary. Then the senator himself came on the phone and told Suero that he was welcome to shoot as many photos as he liked. John Kennedy made only one stipulation: "Remember the dignity of my office," he told Suero. "I won't pose in any way that will hurt that dignity."

On the morning of Thursday, May 6, Suero began his assignment early, snapping the couple over the breakfast table at Dent Place. Jack is immersed in the *Christian Science Monitor* while Jackie pours his coffee.

At this early stage in her marriage, Jackie was trying hard to act as a traditional wife. She herself said of this period that she made sure that Jack "no longer went out in the morning with one brown shoe and one black shoe on."

Igor Cassini, who wrote a gossip column under the name *Cholly Knickerbocker,* reported in 1954 that at the time of his marriage Jack only owned four usable winter suits, frequently reduced in number by his habit of checking out of hotels and leaving one suit in the closet. It was left to Jackie to persuade Jack that a blue serge jacket, a solid brown tie, and a faded pair of black trousers—in

which attire he had once turned up for an important political dinner, much to the dismay of his senatorial aide Ted Reardon—was *not* a good color combination.

With Jack appropriately dressed, the photographer accompanied Senator and Mrs. Kennedy to Room 362 in the Old Senate Office Building. Jack's office was directly across the hall from Vice President Richard Nixon's Senate office. Six years later, the two men fought bitterly for the presidency; but in 1954 relations between them were cordial.

In the first week after they took up residence at Dent Place, Jackie had proudly sat in the gallery to hear Jack speak on the Senate floor in the budget debate. At this period in their marriage, she often worked with Jack in his office, helping him select what she thought he should read and drafting his replies to letters from constituents. "This was a real working session in his office," says Orlando Suero. "It wasn't set up for the camera. Jackie was helping him read and edit materials."

Jackie also did her part by joining the Ladies of the Senate Red Cross and a Senate Wives cultural group that raised funds for local museums and cultural societies. But her greatest contribution was her sophisticated, educated intelligence, one of her appeals to Jack. Jackie helped him by translating

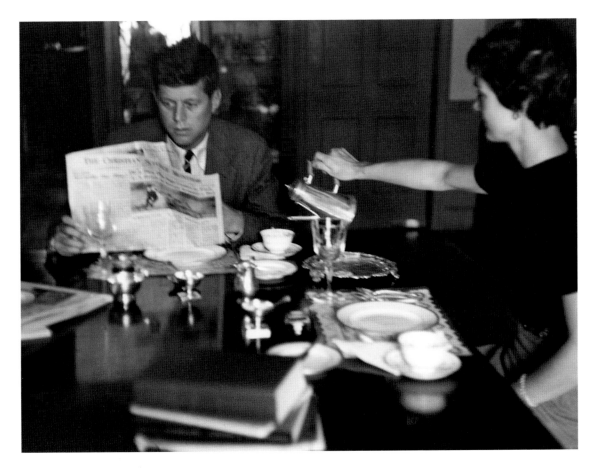

materials from French about the situation in Southeast Asia. Jack took a special interest in French Indochina, which he had visited during a seven-week trip to Asia with Bobby in October 1951. At the time, the French were fighting Ho Chi Minh and his Vietminh forces. In Saigon, the French commander, General de Lattre de Tassigny, had told the two brothers that if the French lost the Mekong Delta, the West would lose Asia.

On April 6, 1954, JFK had delivered an important speech against American support for the French besieged at Dien Bien Phu, nonetheless stressing that a non-Communist regime in Vietnam was essential to the security of all Southeast Asia. The editorial position of the *New York Times* that month had been that "in Dien Bien Phu, the French are heroically fighting the battle of the free. . . . The world's biggest democracy could not stand idly by while communism swallowed small countries and toppled the dominoes of Asia." "No amount of military assistance in Indochina," JFK prophetically warned the Senate, "can conquer an enemy which

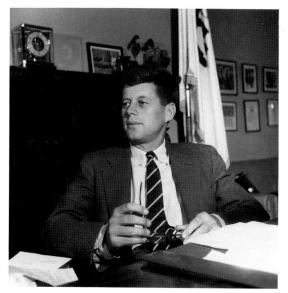
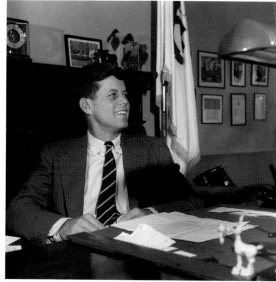

is everywhere and at the same time nowhere, an enemy of the people which has the sympathy and covert support of the people." The French fortress fell on May 7, 1954. "We Won't Surrender! Is Last Word Heard as Dien Bien Phu Falls before Red Hordes," screamed a banner headline on the front page of the *Washington Post and Times-Herald* (the two papers had recently amalgamated) on Saturday, May 8.

In addition to speaking out on Indochina, the junior senator from Massachusetts was gaining recognition in other ways. In January 1954, JFK had abandoned a 1952 campaign pledge and given a major speech backing construction of the St. Law-rence Seaway, which his Massachusetts constitu-ents feared would harm New England's economy. His stance was heralded in the press as statesman-like, although his Boston constituents thought he had committed political suicide. The subject re-mained highly controversial. That first week in May, the *Washington Post and Times-Herald* ran a full-page ad taken out by more than two hundred organizations across the country, urging the defeat of the "Seaway" Bill under a picture showing the St. Lawrence frozen over.

In the first months of 1954, JFK also had at-tracted national attention by condemning the Eisenhower administration's dependence on "mas-sive retaliation," a precursor of his thinking during the Cuban Missile Crisis, when, as president, he edged back from the brink of nuclear war and began developing his "Strategy for Peace" that eventually led to the signing of a test-ban treaty with the Soviets.

In the spring of 1954, the Democratic Party was using JFK as a speaker in the midterm election campaigns for Democratic candidates. Jackie was coaching her husband in public speaking, helping him become a more effective orator by slowing down his delivery and eliminating his jerky hand gestures. She also persuaded him not to make speeches with his hands in his pockets. In spite of his back pain, the young senator strenuously criss-crossed the country to speak at various political rallies. All these commitments meant that the time he actually spent at home in the house at Dent Place was minimal.

Later that year, *McCall's* ran a two-page spread of the Suero photographs. "Pretty Mrs. Jack Ken-nedy, married to a rich and handsome young Sena-tor," the magazine reported, "is determined to help her husband politically, even if it means long hours of hard study." *McCall's* got Jackie's age wrong (she was twenty-four, not twenty-seven) but commented

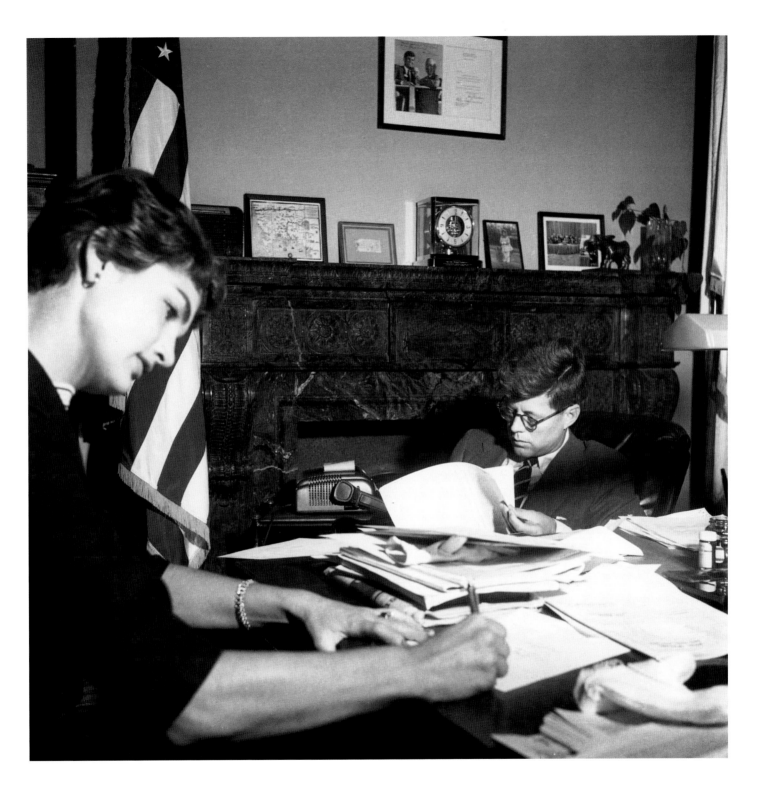

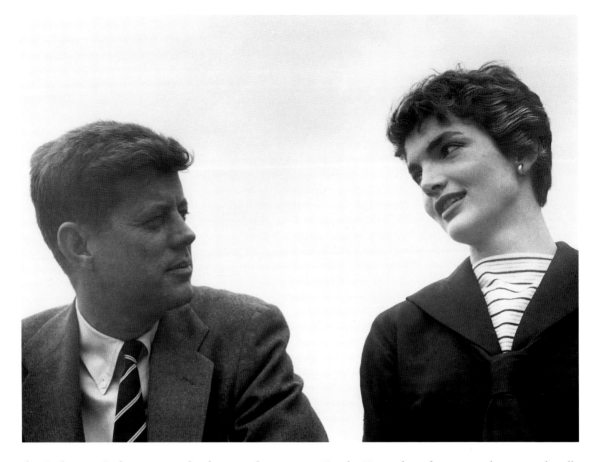

that Jackie was "a decorative and industrious hostess for him. Together they work over his mail and talk out political issues. . . . To supplement her schoolwork Jackie goes often to the Capitol to absorb current events, and so far hasn't missed one of her husband's major speeches. 'He's a fantastic speaker,' she says. 'Always talks fast, to get as much in as possible.'"

*McCall's* also got it completely wrong when it concluded the short writeup by saying that Jacqueline Kennedy was "enchanted with life in politics, and with her favorite politician." Ted Sorensen, Kennedy's assistant, had a totally different take. "Politics kept her husband away too much," he wrote of this period. "Politicians invaded their privacy too often. 'It was like being married to a whirlwind,' she was quoted by one reporter in speaking about their early life. 'Politics was sort of my enemy as far as seeing Jack was concerned.'"

For the Kennedys, of course, politics was the all-consuming passion in their lives. JFK had captured his Senate seat in 1952 largely because of his entire family's wholehearted involvement in the campaign. His opponent, Henry Cabot Lodge, had commented bitterly that he had been drowned in the tea parties organized by the Kennedy women. When JFK ran for president in the 1960 election, the Kennedys, whose motto might well have been "one for all and all for one," campaigned tirelessly all over the country.

One Suero photograph shows the mantelpiece of Jack's Senate office, where there are various framed photos, including one of Jackie as a little girl with her pony. Although it is a delightful photo, it is a surprising one for Jack to display so prominently, since he himself didn't care much for horses. Jackie, who began riding at the age of four, was a passionate horsewoman; Jack preferred sailing and football.

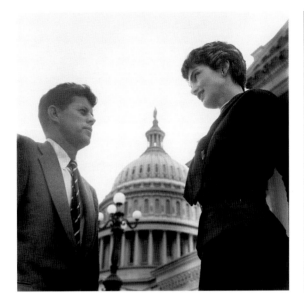

Also framed on the office mantelpiece are a map of Hyannis and the well-known Irish blessing:

*May the road rise to meet you*
*And the wind be ever at your back*
*And may you be in heaven half an hour*
*Before the devil knows you have died.*

Although Jack liked to keep some of the accouterments of the stage Irishman about him, his aides Kenny O'Donnell and Dave Powers realized that this was largely a front. JFK was not the naturally gregarious, backslapping Boston-Irish pol that his grandfather, "Honey Fitz" Fitzgerald, the legendary mayor of Boston, had been. He never even went to a wake unless he had known the deceased personally. Nonetheless, there was one aspect of his Irish heritage that Jack loved—popular Irish songs.

The young Jack Kennedy's inner core of emotion was so deeply hidden, however, that he initially struck his handlers as shy and diffident with crowds. When he ran for Congress, his entry into politics was widely, if not altogether convincingly, ascribed to the propulsion exercised by his father, whose own political career had terminated disastrously. The elder Kennedy had been appointed by President Franklin Delano Roosevelt in 1938 as ambassador to the Court of St. James in London. Confronted by the rise of Nazi Germany, Roose-

velt's ambassador advocated a policy of accommodation with the dictators and took a firmly isolationist stance against America's entry into the war. When Joe Senior declared in a public speech that Britain was "finished," Roosevelt recalled him, at Winston Churchill's instigation. Jack's father insisted on being called "the Ambassador" for the rest of his life, but he was relegated to political limbo.

The Suero photographs taken in the Senate office are remarkable for including ones that show JFK wearing glasses. Apparently, at the time, Jack didn't object to these shots. Later, as he grew ever more conscious of his image, he refused to be photographed with glasses. In defiance of his wretched health, he wanted to project an image of "Vigah!"

During the first few months of 1954, Jackie was particularly worried about the long hours Jack put in at the Senate and would deliver home-cooked meals to his office, frequently featuring his favorite, clam chowder. Sometimes she had lunch with him in the Senate Dining Room. Orlando Suero captured one of those occasions.

That winter Jackie had written and illustrated herself a little book for her eight-year-old half sister Janet Auchincloss. It was titled "A Book for Janet: In Case You Are Ever Thinking of Getting Married

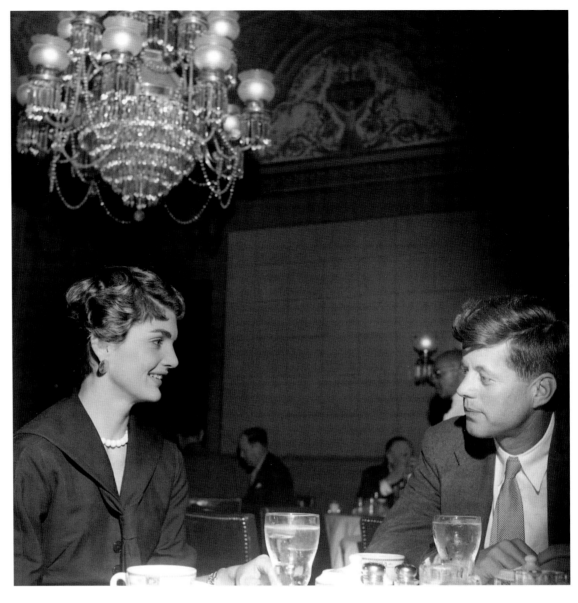

This Is a Story to Tell You What It Is Like." "She drew absolutely wonderful pictures of her waving goodbye to Jack as he left the house in the morning and, of course, they were all funny caricatures," Jackie's mother Janet Auchincloss recalled. "There was one of the dome of the Capitol all lit up at night, very dark, and there was a rhyme underneath it about when you saw the light burning there late at night and he wasn't home yet, you knew that the country was safe because he was working."

The U.S. Capitol figures largely in the Suero photo sessions. Jack and Jackie are photographed dramatically silhouetted against a backdrop of sky and Capitol dome, and against the steps of the Capitol. Here, in the Senate Caucus Room on January 2, 1960, Kennedy chose to announce that he was a candidate for the presidency.

Jack's personal secretary appears in some of the office sequences. Mrs. Lincoln guarded her boss jealously, protecting him as much as possible and giving him total devotion and loyalty. Throughout

their twelve-year association, in spite of Jack's informality with friends and colleagues, he always addressed his secretary as "Mrs. Lincoln." Evelyn Lincoln's memoir, *My Twelve Years with John F. Kennedy,* published in 1965, gives a vivid account of the day-to-day running of his Senate office at the time of Suero's photo sessions. Although she was totally dedicated to JFK, Mrs. Lincoln unconsciously reveals a boss who was altogether demanding and considered his employees totally at his beck and call. When JFK became president, he even urged her to live at the White House so that she could be available twenty-four hours a day—a suggestion strongly vetoed by her husband, Abe.

In the spring of 1954, even the devoted secretary noted her boss's increasing irritability and outbursts of temper as his back pain became almost unendurable. It was so bad that she even considered looking for another job. "The one question you could never ask Jack Kennedy," Mrs. Lincoln later commented, "was 'How are you?' If you did, he simply wouldn't answer. He never wanted to talk about his health."

Among Suero's photographs, taken both at the Dent Place house and at the Capitol, are many that include K. LeMoyne Billings, who had been Jack's roommate at Choate Preparatory School. "Lem" had become almost like an adopted brother in the Kennedy family. In the memorable shot of Jack and Jackie leaning over the balcony, they are actually talking with Lem, seated in the garden below. He was one of the few close friends Jack had had before his marriage who became a close friend of Jackie's as well. From time to time, Lem also came to Jack's Senate office to help. After one such working session, Suero obtained some shots of the inseparable threesome perched on top of a wall at the U.S. Capitol. "Lem was putting his arm round Jackie to make Jack jealous," the photographer remembers. "They were all just kidding each other. Jackie was telling Jack 'If you don't watch yourself, I've got Lem.'"

It was Lem who had taken Jackie aside when her engagement was first announced to warn her that she was marrying a man set in his bachelor ways. Lem was right. Not least of Jackie's trials in adjusting to Jack in their first married home was her husband's habit of constantly filling the house with family members, friends, and politicians. Not only was Lem Billings an almost permanent house

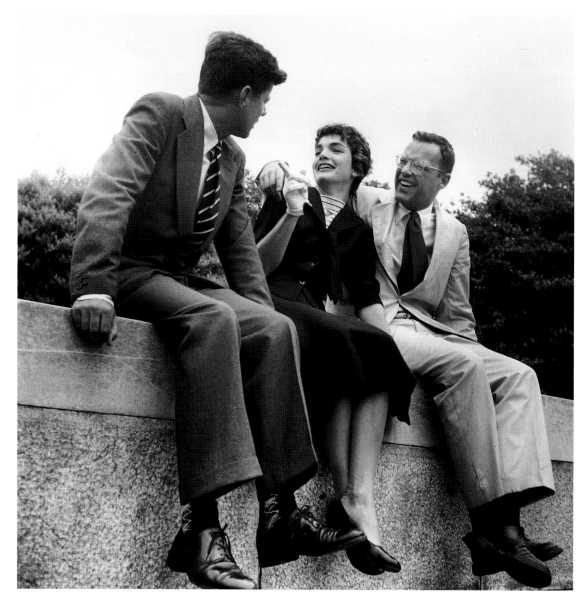

guest; he brought his big dog along, too. Jackie frequently found herself left to take care of the dog. Because she was accustomed to the spaciousness of her stepfather's Merrywood estate, the two-bedroom house at Dent Place must have seemed small to Jackie, definitely too cramped to have Lem and his dog underfoot all the time.

One of Kennedy's most endearing traits was the fierce loyalty he showed toward the friends of his youth. Even after he became president, Jack wanted his old friends around him—such friends as his Harvard roommate Torby McDonald and crew members of PT-boat 109 like Red Fay, nicknamed "Grand Old Lovable." The relationship with his old prep school roommate was, however, especially close. The explicit and irreverent letters that passed between young Jack Kennedy and Lem Billings, and Lem's later reminiscences, provide an intimate portrait of JFK in his most unguarded moments.

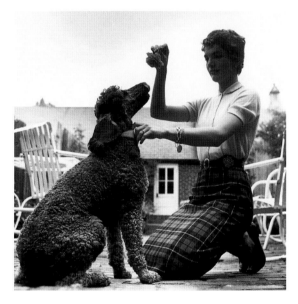

In early 1955, when Jack Kennedy lay close to death after his second back operation, Joe Kennedy asked Lem to go down to Palm Beach to help pull Jack through. Sadly, after JFK's assassination, there was no one to pull Lem through. Jack's death devastated him.

On Sunday, May 9, Suero photographed Jack being interviewed by local Washington television station WTOP, an affiliate of CBS, for its *Man of the Week* program. The program listing stated only that the junior senator would answer questions. Since the fall of Dien Bien Phu was the big news of the week, this topic may have dominated the discussion. "I don't have any recollections of the interview," says Suero, "because in those days you couldn't shoot photos inside a TV studio because they didn't have blimps [housings to go over a camera] to eliminate the sound of a shutter clicking, so I had to wait outside."

In 1954 television, available only in black and white, was still something of a novelty. By today's standards, the studio in this photograph appears primitive. At the time, even the main network newscasts of the day were only fifteen minutes in duration, and interview programs had not yet caught on. In his run for reelection in 1956, President Eisenhower was to decline invitations to televised debates with his opponent because he regarded television as inconsequential. In the 1950s, newspapers and magazines still dominated the media.

It was a tribute to JFK's savvy in media matters that, early on, he recognized the potential impact of

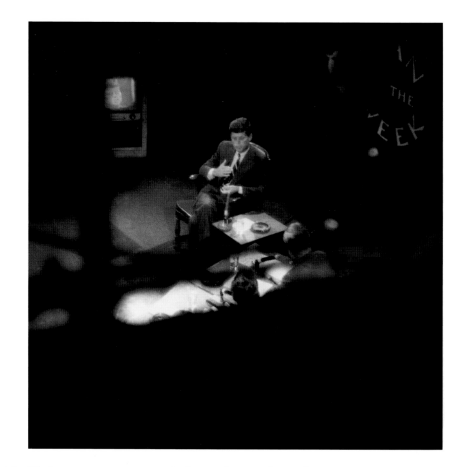

television. This *Man of the Week* interview was an
opportunity for Jack Kennedy to continue honing
the telegenic skills that, in 1960, were to prove
decisive in the televised debates with Richard
Nixon. "There are those," wrote *New York Times*
reporter James Reston, who "feel Mr. Nixon blun-
dered it away by going on television with Young
Lochinvar." On television in 1960, "Young Lochin-
var" came across as engagingly youthful and likable,
self-assured but with a self-deprecating sense of
humor. During Jack's presidential campaign, his
father, who had invested heavily in early Holly-
wood, spent enormous sums of money buying
network air time to show a promotional film on the
candidate in key states, a major innovation in
political advertising. The film began with the bow
of a PT boat cutting through the water to remind
viewers of JFK's heroic wartime exploits. With this
kind of Hollywood-style buildup, the effect JFK

had on audiences during his 1960 campaign was as
much that of a popular movie star as of a politician.

Once he had won the White House, JFK was
the first president to hold televised press confer-
ences. It was a big step up from Franklin Delano
Roosevelt's "Fireside Chats" on radio, and every
president since John F. Kennedy has regarded
television as critical for mass communication.

The senator did not ignore the more traditional
press, though. He was adept at manipulating the
media by taking numerous leading journalists into
his confidence, thereby completely disarming
them. Arthur Krock of the *New York Times*, Hugh
Sidey of *Time* magazine, Ben Bradlee of the *Wash-
ington Post*, columnist Joe Alsop, and many others
fell under the spell of JFK's charm and wit. The age
of media celebrity had just arrived.

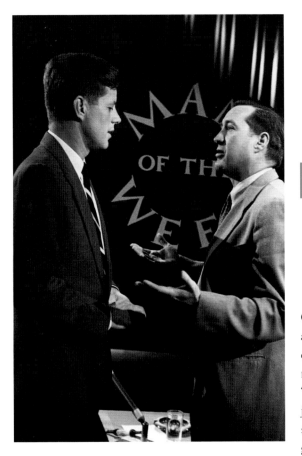

On Saturday, May 8, Senator and Mrs. Kennedy attended a dinner at the home of newspaper columnist Joe Alsop, then went on to an engagement listed in Evelyn Lincoln's office calendar as a "Small Dance at River's End." Suero provides a joyous image of Jackie floating down the narrow staircase of the house at Dent Place in a crinoline gown, a perfect dress for dancing, while Jack gazes up at her in rapt attention. It was admiration tempered by his usual deprecating humor. "Jack said something like 'Jackie, you look absolutely gorgeous,'" Suero relates, "but he was always kidding her, so he followed up this compliment with 'but if you stood sideways, you'd disappoint half the men in America!'"

Jackie responded to his teasing by solicitously straightening Jack's bow tie.

"I thought they looked like a couple of college kids going to a prom," reflects Suero. "By this time they were treating me very casually. Jack said 'Why don't you stay here, Orlando, and when we come back we'll do some more pictures.' So I made myself comfortable and read for a couple of hours. When they came back, Jack was all ready to go on with the photo session, but I thought they looked tired so I said 'No, Senator, we'll take it up again tomorrow.'"

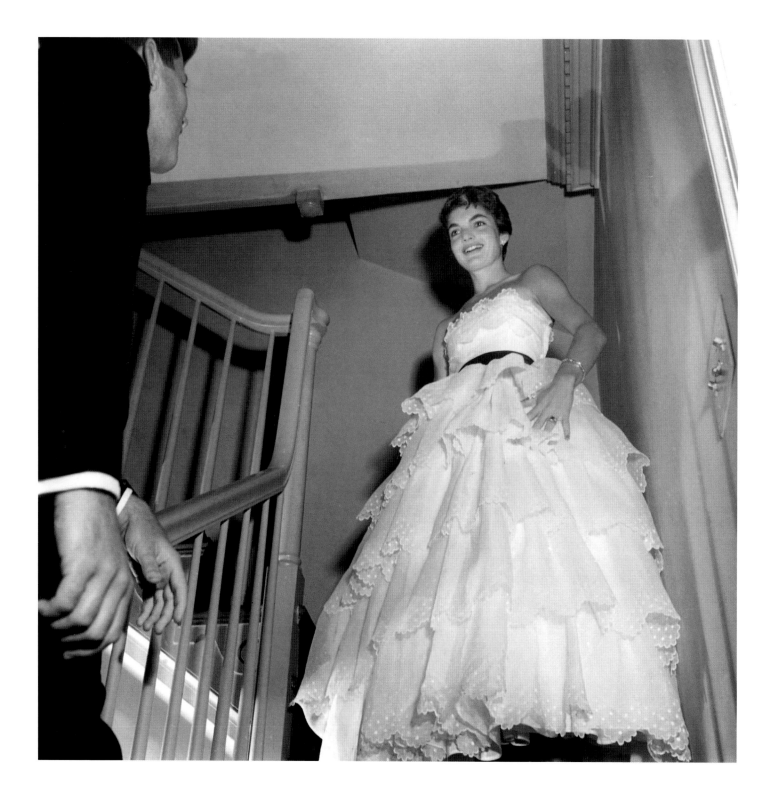

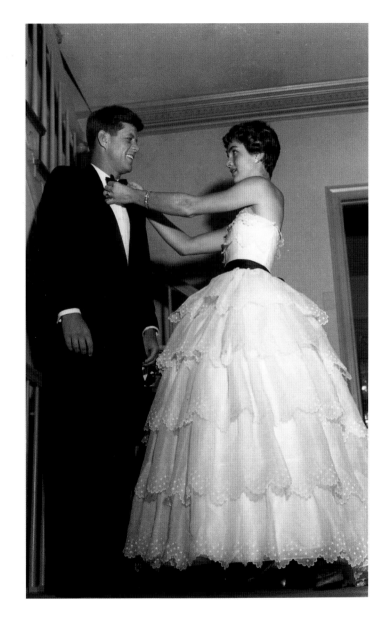

## A Student at Georgetown University

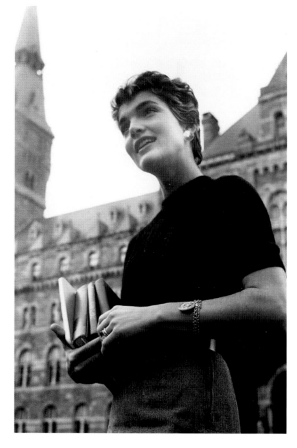

Only four blocks away from the house at Dent Place was Georgetown University. The neighborhood, which was not as fashionable and expensive in 1954 as it is today, then had many students living in it. To keep up with Jack's political interests, Jackie had enrolled in an American history class at the university.

It was this that had given Suero the initial idea for his photo assignment. "I was riding a bus in New York," Suero says, "and just happened to read this item in a newspaper that Jacqueline Kennedy was a young wife, a hostess, and a student. I thought it would make an appealing story."

The *McCall's* piece that fall focused, in fact, on Jackie's studies. The Suero photos appeared under the heading "The Senator's wife goes back to school." *McCall's* noted that "Jacqueline Kennedy is not content" with helping her husband. "Because 'he's a Senator,' she decided she ought to 'know more.' Shortly after the Kennedys moved into their Georgetown house, Jackie, who's a George Washington graduate, decided to go back to school. At Georgetown University's Foreign Service School, she's studying political history. According to one of her professors, she's a remarkably good student. No nonsense, he says, about cutting classes because a diplomatic reception kept her out late the night

before. . . . Busy as they both are, the Kennedys manage to lunch together almost daily, which gives Jackie a chance to talk over school problems while they're still fresh."

"Jackie is the only member of her class who has a Senator husband to help her with her homework," enthused *McCall's*. Whether thanks to such help or despite it, Jackie got a B in the course. "It fascinates Jack to compare her classroom theories with his own practical experience. Evenings she helps him with his major speeches." The magazine went on to say that "in class Jackie asks questions her teachers describe as brain twisters. She's one of 20 girls in the foreign service school."

At first her very presence caught her professor, Jules Davids, unawares. "Jules didn't recognize Jackie Kennedy in her first day in class," his wife, Frances Davids, related years later. "In those days, in the 1950s, Georgetown was principally an all-

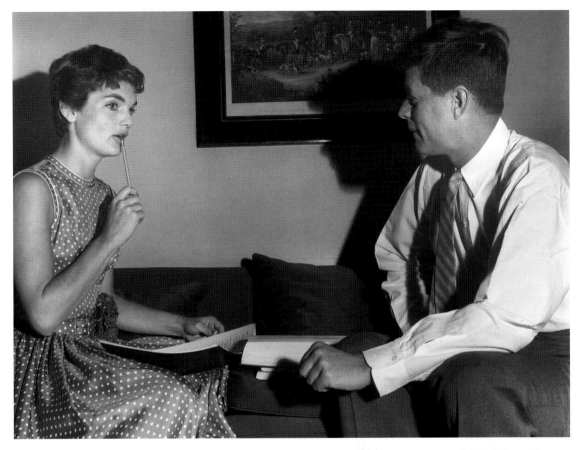

male school. When Jackie came in, the class applauded, and he thought it was simply the young fellows applauding the presence of an attractive young woman in the class. He didn't realize until after the lecture that she was the Senator's wife."

The class took as its theme political courage, and it seems likely that Jacqueline Kennedy, inspired by her instructor, gave Jack the idea for his book *Profiles in Courage*. In it Kennedy used examples of historical figures to show how one could rise from self-interest or mere partisanship to statesmanship.

Kennedy began work on the manuscript while recuperating from his back surgery at Palm Beach in early 1955. Ted Sorensen contacted Davids in January, asking whether he would be willing to help the senator put together the text. The thirty-four-year-old untenured assistant professor agreed and for a fee of $700 drafted four chapters—those

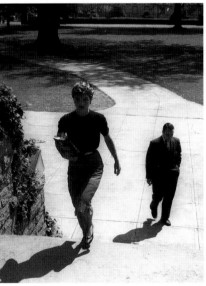

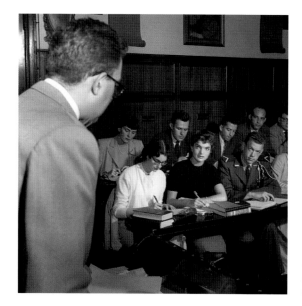

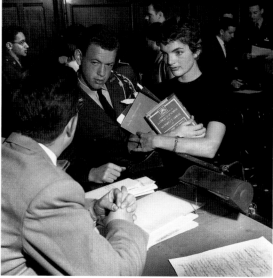

on Daniel Webster, Sam Houston, Lucius Q. C. Lamar, and George W. Norris, plus an introductory or overview essay on the subject of political courage itself. Sorensen and others drafted other chapters. "I feel quite sure that Jacqueline recommended me to Kennedy," Davids said later, "and this led to Sorensen's call. Since the book was to be on political courage, I have always felt that my lecture, and Jacqueline's presence in my class, were connected directly with triggering John Kennedy's interest in the subject of political courage in American history. It is conceivable that this was coincidental; but I believe not likely." Later, after Harper's publishing house turned down Kennedy's proposal, Davids drastically reorganized the material and sharpened its focus. Kennedy acknowledged these crucial efforts in the preface of the book, which appeared in 1956. Davids, he wrote, "assisted materially in the preparation of several chapters."

At the age of twenty-three, Jack (with considerable assistance from *New York Times* journalist Arthur Krock) already had turned his senior thesis at Harvard into the book *Why England Slept,* which came out in 1940. It was timely in that its publication coincided with the Nazi blitz against England, but Joseph P. Kennedy Sr. made sure it would be a best-seller by secretly buying up more than 30,000 copies and stashing them in the basement and attic of the Hyannis Port house. Thanks in part to Joe Kennedy's tireless promotion, Jack's second book won a Pulitzer Prize in 1957, giving Kennedy the aura of a brilliant young intellectual and thus gaining ground for him among presidential hopefuls. "You would be surprised," Jack's father had written him from England when *Why England Slept* was being knocked into shape, "how a book that really makes the grade with high-class people stands you in good stead for years to come."

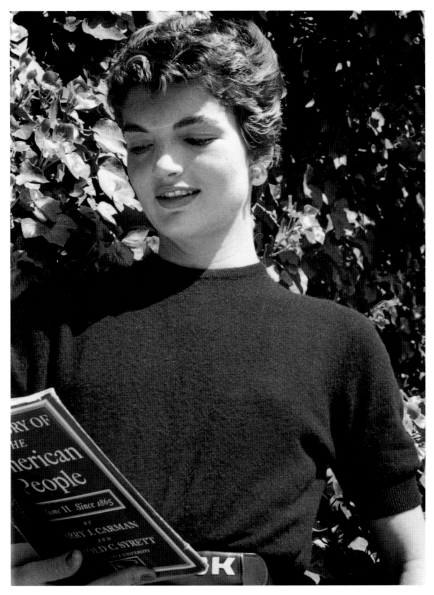

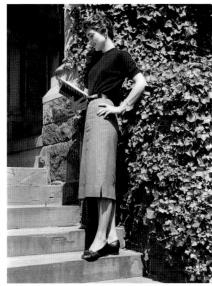

Jules Davids taught at Georgetown University for more than forty years, retiring in 1986. Among his later students was Bill Clinton, a Georgetown grad in 1968. When Davids died in December 1996, President Clinton wrote Frances: "He was a wonderful professor, and I will always be grateful for all that he taught me." Jack Kennedy might have said "grateful for all that he taught Jackie." JFK dedicated *Profiles* to her.

Other pictures Suero shot in the Georgetown sequence show Jackie around campus with fellow students. She and a friend watched a candidate for

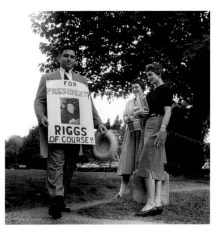

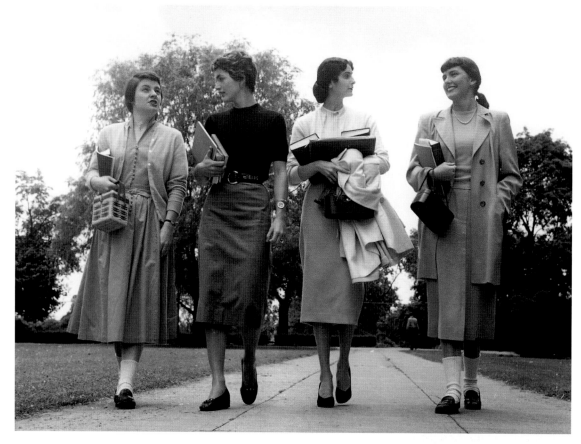

student office parade by, wearing a promotional poster. At the end of class, she and a few of the students headed for a Good Humor ice cream van parked at the gate of the campus. Some of them bought cones and started licking them. Suero suggested to Jackie that he take a photograph of her eating an ice cream, but she, a true product of Miss Porter's School, a finishing school for young ladies in Farmington, Connecticut, was too conscious of her dignity and declined. In her mind, eating ice cream in public was inappropriate behavior for a senator's wife. Later that year, after she had seen some of the Suero photographs, she wrote him a note from Hyannis Port. "If I'd realized," she told him, "what a wonderful photographer you were, and how nice *McCall's* was about doing the story, I would never have been the jittery subject I was. Poor Orlando! Remember I wouldn't even eat a Good Humor. I was so lens-shy."

Obviously captivated by the extraordinary beauty of Jacqueline Kennedy, Suero took some closeup shots of her posed against the brick wall at the end of the small back garden at Dent Place. The photographer picked a flower for Jackie to hold. She is gazing wide-eyed into the camera with her chin buried in the single blossom. Suero remembers his subject as "more reserved" than Jack, "really very shy, stunningly beautiful," but surprisingly diffident about her looks. In her handwritten letter from Hyannis Port, later that year, Jackie thanked Suero for the attractive spread in *McCall's*. "It couldn't have been a nicer story, and they are the only pictures I've ever seen of me where I don't look like something out of a horror movie. I wonder if you could send us some of the pictures you took, ones of us together and the ones you took of my head in the garden." Jacqueline Kennedy continued: "I waited breathlessly for them all spring, but no sign! Lem Billings was thrilled with his and so were Bobby and Ethel. I will buy a new scrapbook especially to paste them in so I do hope you can send some. So many thanks, Orlando, and best from us both." Suero had, in fact, already mailed a set of photographs to her, but the package seems to have gone astray over the summer months. Jack and

Jackie, having left Dent Place, were again living like gypsies. At the time Jackie wrote to Suero in October, Jack was about to go in for surgery that might well make her a widow. Even Jack's father had begged him not to undertake the risky procedure. In these anxious circumstances, Suero's photographs must have appeared especially poignant to her.

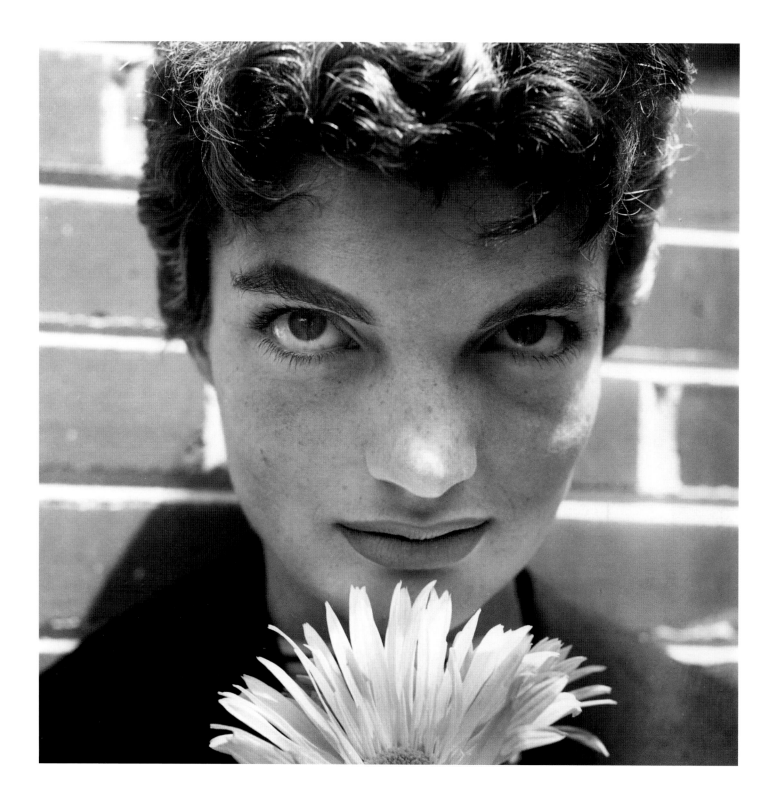

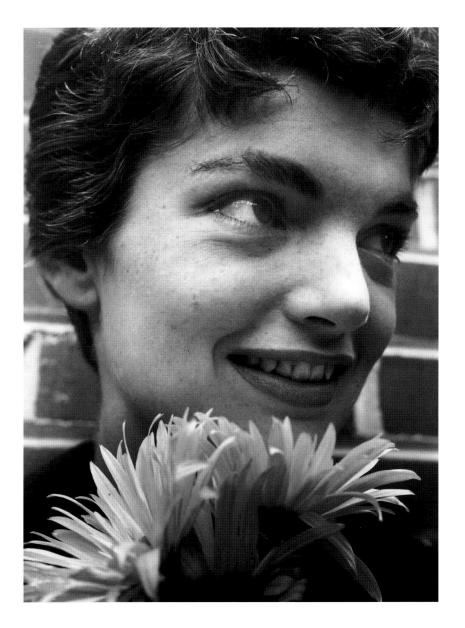

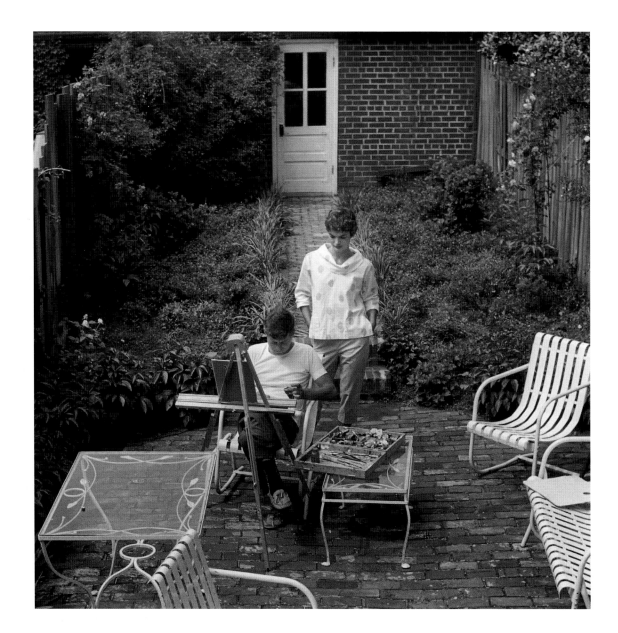

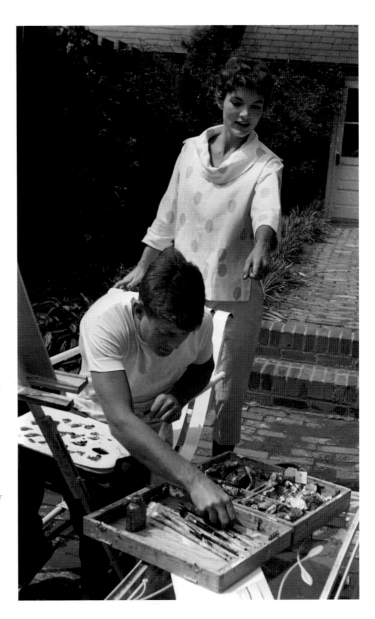

While making the effort to share Jack's political interests, Jackie also hoped to draw him into her own artistic pursuits. At their first Christmas together with the Kennedy family in Palm Beach, she gave him a very expensive set of oil paints. "Almost immediately," said Lem Billings, "all the Kennedys descended upon it, squeezing paint out of the tubes, grabbing brushes, competing to see who could produce the greatest number of paintings in the least amount of time. They went at it from early morning until late at night, starting outdoors, and then when it became too warm, they all retreated into the house, dripping paint and turpentine across floors and carpets. Jackie was stunned. She stood there with her mouth hanging open, ready to explode." By the time the family members had finished with the set, the tubes were all squeezed out of shape, and Jackie was almost reduced to tears. She had meant the present seriously; the Kennedy siblings saw it as a huge joke—a sissy gift for a macho Kennedy. Still upset the day after Christmas, Jackie called Evelyn Lincoln to make sure that the couple could move into the house at Dent Place as soon as they returned to Washington.

A few months later, the painting set came back out. Over several weekends in April and May, Jack again took up the set of oil paints, sitting outdoors in the small garden at Dent Place. By this time he had read the biography of Winston Churchill, one of his heroes, that Jackie had given him to demonstrate that it was okay for real men to paint. With Jackie's encouragement, Jack set about his new hobby with characteristic intensity—if minimal artistic skill. "I do recall," says Suero, "that at one point Jackie was making a suggestion about color or something and Jack said 'Wait a minute! *I'm* doing it.' He was a little disturbed that she had broken his

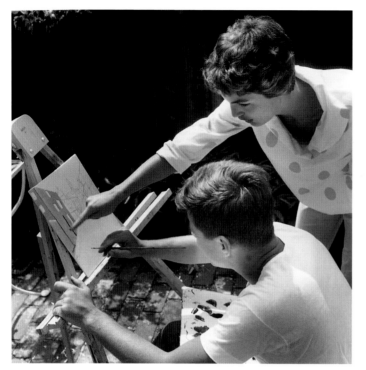

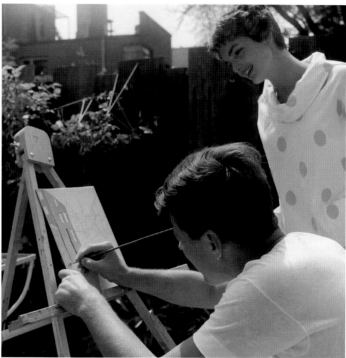

concentration. He was totally absorbed in his painting."

Over the weekends that he spent amusing himself painting, Jack produced several pictures, mostly reflecting his love of the sea. Some were scenes of a harbor near Hyannis Port. Suero documented how proud Jackie was of Jack's efforts. She took one of the paintings to be framed at a shop in Georgetown. "She was very particular when she got to the shop," Suero remembers. "She discussed what she wanted in great detail. She had very definite artistic tastes, and there was quite a bit of time spent making her choice." After carefully choosing the frame, Jackie carried the painting home, and Suero snapped her hanging it on the wall (the nail holes later becoming part of the damage claim when the Kennedys moved out).

The following year, while recuperating in Palm Beach from his terrible surgery, Kennedy continued his artistic amusements, painting propped up in bed until his mother complained about the oil colors all over the sheets. Rose Kennedy was further horrified one morning to find that Jack had taken some of her cherished pictures in the Palm Beach house outside by the swimming pool for copying—regardless of the fact that they were out in the hot sun and frequently getting splashed as the Kennedy siblings dove into the pool.

Once Jack Kennedy recovered and returned to Washington, there was no more time for art; Suero may have taken the only photos in existence of JFK painting in oils. Jack was so pleased with his Dent Place paintings that he gave one or two of them as presents to Bobby and Ethel and other family members. Two of them accompanied him to the house on N Street and later to the White House.

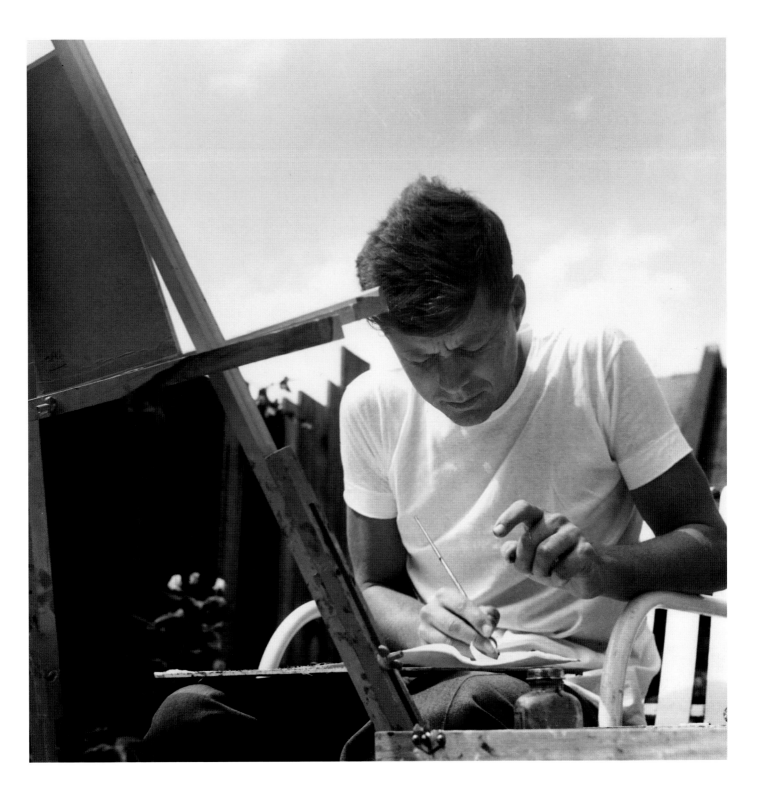

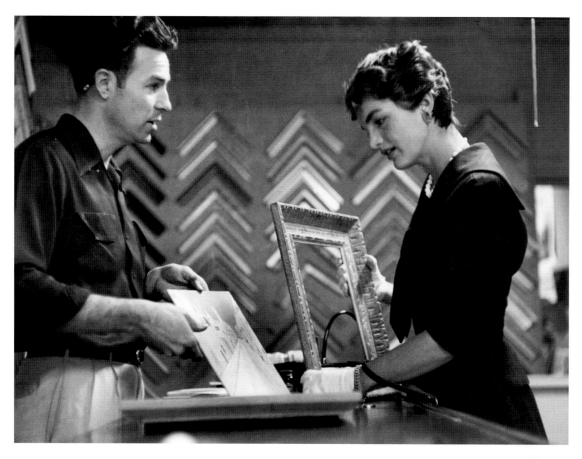

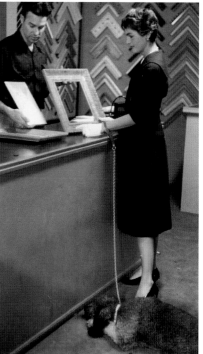

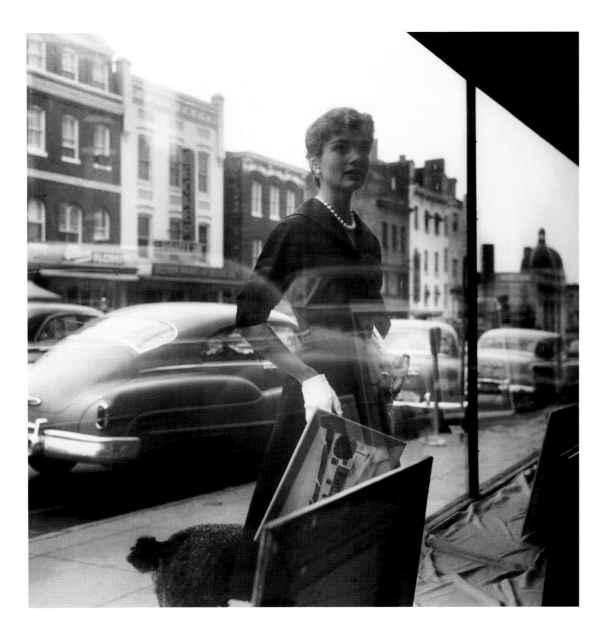

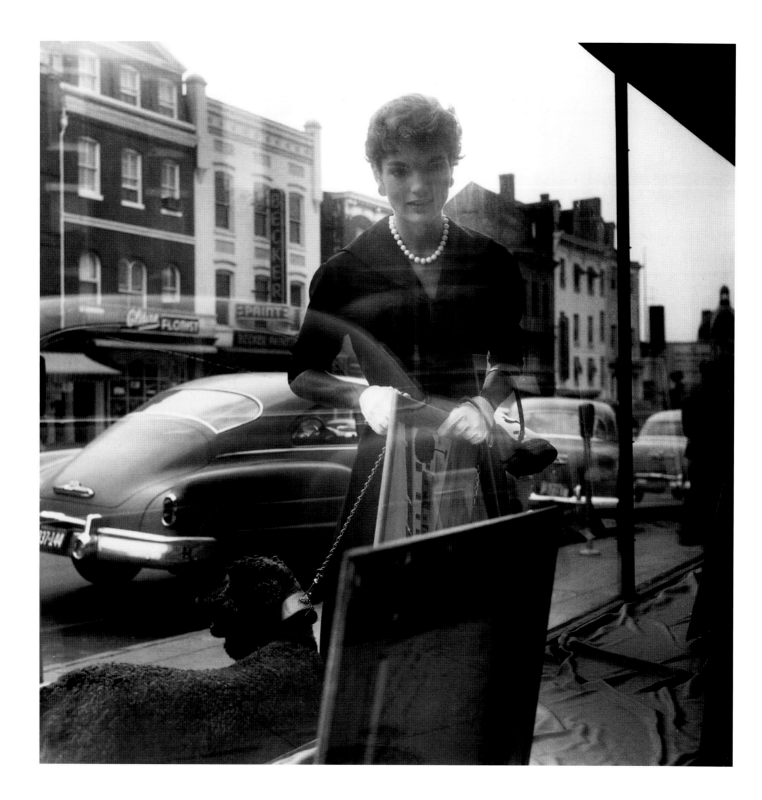

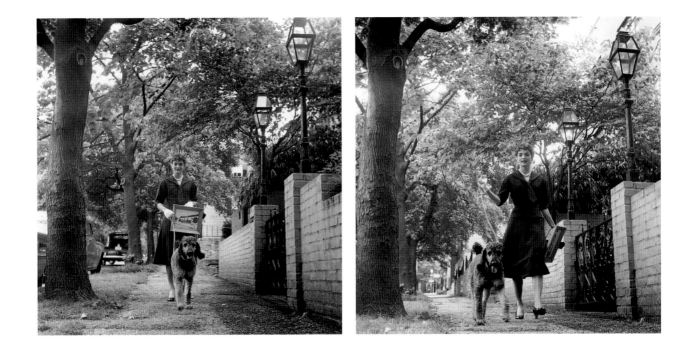

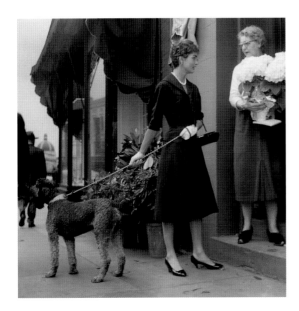

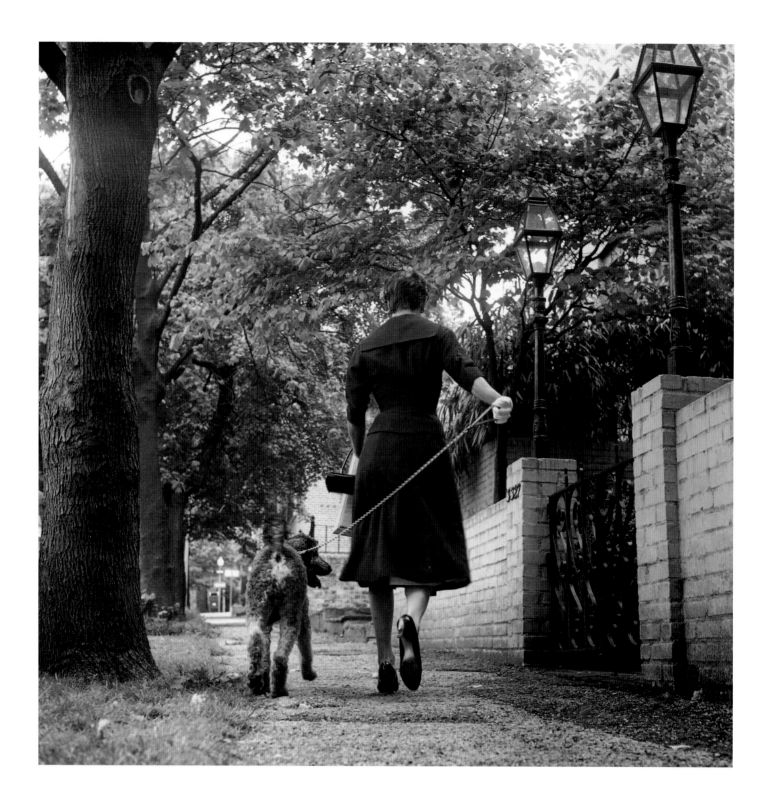

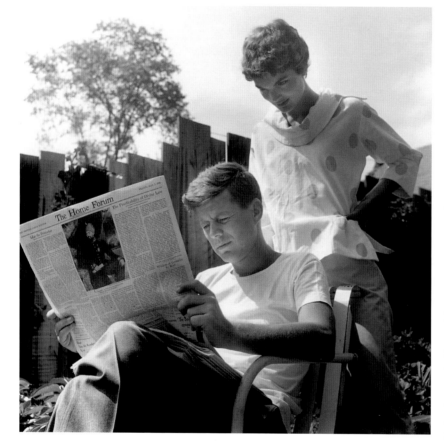

All his life, Jack Kennedy devoured newspapers and magazines. Here he is shown in the yard on Sunday morning, May 9, absorbed in the May 7, 1954, issue of the *Christian Science Monitor*. Suero photographed him reading the same paper over breakfast before setting out for his Senate office.

JFK developed a phenomenal ability to read material quickly. For several weeks in the spring of 1954, Jack and Bobby had been traveling together to Baltimore to attend a speed-reading class at the Johns Hopkins University's evening college. Professor Elton Y. Mears taught the class, entitled "How to Read Better and Faster." It met Tuesday evenings, 8:30–10:30, and the brothers had to drive more than an hour each way to attend it. "This is a course for the normal reader who wishes to improve his reading ability," read the catalog description. "It aims to increase reading skills, to stimulate greater interest in reading, and to make the individual a more alert and responsive reader."

By May JFK had given up this weekly commute to the Hopkins Homewood campus because of back pain, but the class was a success for him. When he became president, aides marveled at his ability to digest written material and grasp the essential facts almost at a glance.

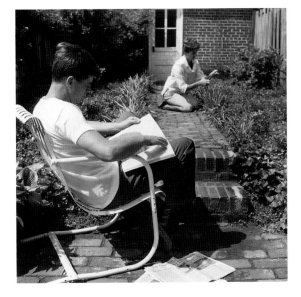

While Jack reads, Jackie does some gardening. The couple had hired a gardener, but when the man presented his bill, Jack was horrified at such a big amount for so small a yard. According to Evelyn Lincoln, he left it unpaid for months.

During the time at Dent Place, Jackie learned domestic skills from housekeeper Mattie Penn. Mrs. Penn, who lived in the basement apartment, came with the house. Very much a part of the family, she would work for the Childs for more than forty years. It was Mattie Penn who guided the young bride through the intricacies of keeping house and planning formal dinner parties. "Mattie Penn runs the house," said *McCall's* magazine in its October spread on the Kennedys, "calls the Kennedys 'the children,' and gives Jackie a big grocery list. . . . Jackie's no cook but she sets a fine table, will take ten, but prefers six, at her dinners." The magazine also noted that Jackie had to do "careful planning of schedules that are subject to quick change, for she never knows when the Senator will get home, or whether he'll want to face company." Sometimes it was Jackie who had to face company unexpectedly. In her first weeks at Dent Place, Jack called her at 11 A.M. one morning to announce that he was bringing forty guests home for lunch. She dashed round the corner to a little Greek place for a ready-made casserole.

There is a famous story about one of Jackie's attempts to cook dinner in her first married home. It must have been on Mattie's night off because, as

Jackie herself describes, it turned into a total catas-trophe:

Evelyn Lincoln called and said Jack was leaving the office, so I started everything. I'd heard those silly stories about the bride burning things and I just knew everything was going right when suddenly, I don't know what went wrong, you couldn't see the place for smoke. And when I tried to pull the chops out of the oven, the door seemed to collapse. The pan slid out and the fat splattered. One of the chops fell on the floor but I put it on the plate anyway. The chocolate sauce was burning and exploding. What a smell!!!!! I couldn't get the spoon out of the chocolate. It was like a rock. The coffee had all boiled away. I burned my arm, and it turned purple. It looked horrible. Then Jack arrived and took me out to dinner.

Jackie definitely needed Mattie, who helped to prepare tempting meals for Jack, both to eat at home and to deliver to the office for his lunch, the favorite being clam chowder. Due to worsening health problems, Jack's weight in the first year of his marriage plummeted from 175 to 140 pounds. He tried to make a joke of it, telling his sister Eunice: "Don't worry. It's nothing serious. Just a result of Jackie's cooking."

John and Jacqueline Kennedy were to remain in touch with Mattie Penn long after they moved out of Dent Place. When Jack went for his double spinal fusion operation, Mattie sent him a note to cheer him up. On January 7, Jack wrote back:

Dear Mattie:

Many, many thanks for your very kind message to me when I was in hospital in New York. Hospi-tals are gloomy places, I am afraid; and it makes a tremendous difference when friends remember you as you did.

The letter is typed on his Senate office letterhead but mailed from Palm Beach where Jack was recu-perating. At the end Jack has appended a note in his own hand: "Many, many thanks, Mattie. If you have any spare time, hope you will come and cook me a dish of collards as they will kill me or cure me." Underneath Jackie has added a greeting of her own: "How we miss you Mattie, lots of love and happy New Year from us both. Mrs. K."

There is another note from JFK dated February 12, 1960, on his "John F. Kennedy for President" campaign letterhead, in which he thanks Mattie for her expression of support for his candidacy. When Kennedy was elected thirty-fifth president of the United States, he sent Mrs. Penn an official signed, inaugural photograph of himself in a silver frame with the presidential seal, which she trea-sured for the rest of her life.

The Childs family also has kept a letter, signed by Kennedy aide Dave Powers and dated Novem-ber 21, 1961, making arrangements for Mattie to have a special tour of the White House on Novem-ber 28. The three Childs grandchildren, Terry, Blair, and Christopher Childs, fondly remember Mattie telling them when they were children about when President and Mrs. Kennedy invited her to the White House and sent a chauffeured limousine

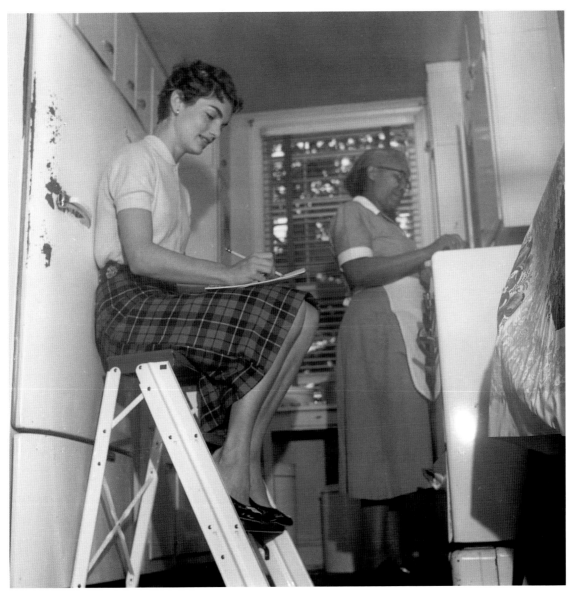

to fetch her. Presumably this was the occasion. The following week, another letter came to Mattie from the White House, dated December 5, 1961, this time signed by Evelyn Lincoln. This letter thanks Mattie for "a scrapbook of clippings and storybook that you brought to the White House the other day. It was certainly a thoughtful gesture for you to remember Caroline in such a nice way."

"The time that Mattie spent with the Kennedys certainly left an indelible mark on her, and their thoughtful gestures over the years only reinforced her deep affection for them," says Christopher Childs. "Here is the President of the United States keeping in touch with a woman of very humble background, who meant a lot to him and Mrs. Kennedy. This is a side of the Kennedys we seldom hear about. Mattie used to talk about them all the time. She kept scrapbooks on the Kennedys and had an enormous collection of clippings in her room." "Mattie was a wonderful woman," says Terry

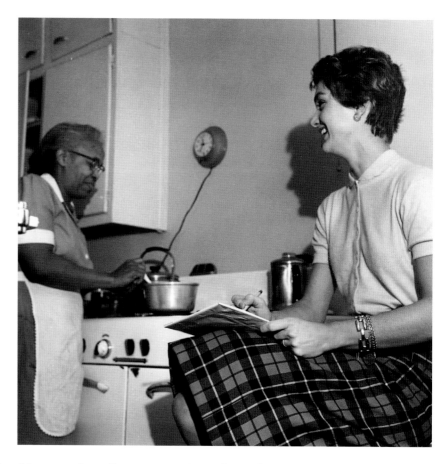

Childs. "We kids loved her. Mattie used to tell us wonderful stories about her time working for the Kennedys."

Mattie Penn, who came from the South, had married a man—always just called "Penn"—who worked as a cook on the railroad. In the mid-seventies, after her husband died and when it came time for Mattie to retire, she moved to Philadelphia to live with a niece.

Even with Mattie's help, not everything went as planned for Jackie. Shortly after the Kennedys moved to Dent Place, Evelyn Lincoln received a telephone call one morning from a Baltimore trucking firm asking where it should deliver "the fish." Slightly irritated at the intrusion, Mrs. Lincoln told the man to take it to the senator's home address,

3321 Dent Place. There was a pause. "Are you sure?" the man asked. Lincoln responded tartly that of course she was sure. Why would one deliver fish to an office address! Mrs. Kennedy had obviously ordered the fish for the dinner party she was giving that night. The man on the phone still sounded dubious but agreed to do as instructed.

It was after dark when Jack Kennedy drove himself home. He was startled to find, as he tried to drive into the garage, that a long, wicked-looking snout with two beady eyes was staring out at him. On his honeymoon in Acapulco, Jack had caught a nine-foot sailfish. He was so proud of his exploit that Jackie arranged for the fish to be stuffed so that it could hang in his office. The delivery man had been right. The fish was *not* intended for the dinner table.

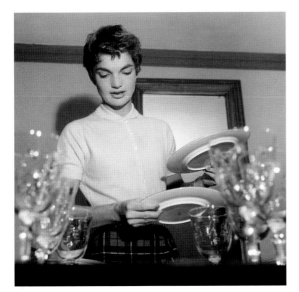

That second week in May, Suero chronicled
Jackie's first formal dinner party. The photographer
followed her day-long preparations until the final
moment, when Jacqueline Kennedy, looking abso-
lutely stunning in a white strapless evening gown
and a three-strand pearl necklace, leaned over the
dinner table to light the candles.

"She was falling-down beautiful—gorgeous,"
Suero recalls. "When she started to light the candles
I said to myself 'Oh, my God!' It was one of those
moments when a photographer can see that he has
a marvelous shot. I bounced the flash off the ceil-
ing as a fill to hold the drama of the moment. That
way the film would register the lights of the candles,
and the background would go darker. I kept think-
ing 'She's a princess!' I appreciated what the photo-
graph would show as I was shooting.

"Many photographers can go along shooting and
not realize what the end product will be. The great
advantage for me was that I had worked in a dark-
room as an exhibition printer for the Museum of
Modern Art in New York. That meant I knew what
could be done in the printing of a photograph to
enhance and glorify it. To be a photographer, you
should walk before you run. It's important to have
this darkroom experience so you know what can be
done." Whatever the technical skill involved, Suero

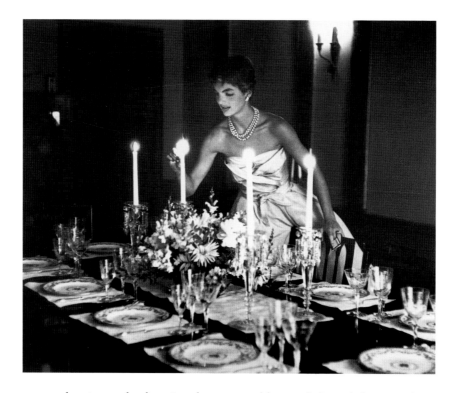

captured an image that has since become world famous. Forty years later, when Jacqueline Kennedy died, on May 19, 1994, this photograph was reproduced in magazines all over the world.

The Scots have a phrase—"calamitous magic"—to describe the kind of haunting beauty that seems fated to attract dramatic, possibly tragic, happenings to its possessor. Suero's candlelit images are imbued with that sense of "calamitous magic."

Once, when asked what single word he would use to describe his wife, Jack called Jackie *fey,* a Scottish word that describes people with an otherworldly quality, individuals with almost a glimmer of doom about them, some would claim.

Close friend Charles Bartlett saw some of that "feyness" in Jack as well: "I never expected to know anybody," Bartlett recalled, "who had this sort of

light and this marvelous wit and a great generosity of spirit. Jack was selfish, too, and he was spoiled and he had a lot wrong with him. But there was something that was very luminous about Jack."

The incandescence around the dinner table that spring night in May 1954 did not just come from the candles.

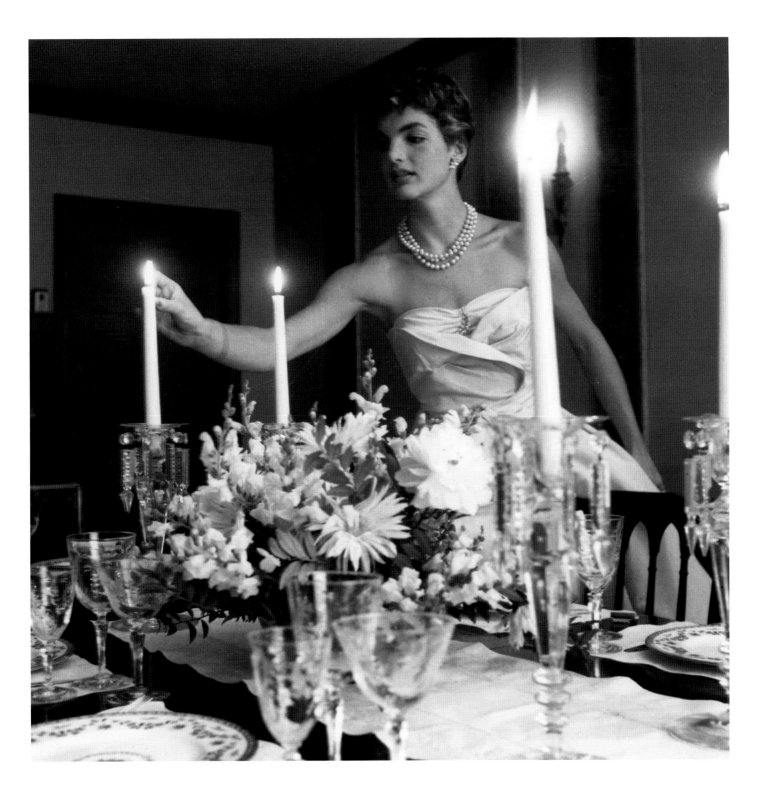

On Saturday afternoon, Jack and Jackie teamed up with Bobby and Ethel to walk to a park so that the brothers could amuse themselves with a football. Suero pictured them straggling down a Georgetown street to a nearby park that doubled as a recreation center. The park is still there today.

"Jack was throwing passes in the street and Jackie kept telling him to look out for cars," says Suero. "Georgetown is still a college town—but in 1954 it was much more quaint and sleepy than it is today, so there wasn't that much traffic."

In spite of being casually dressed in shorts and sneakers, Ethel wears a pearl necklace. Jackie is sporting a pair of "Capri pants," three-quarter-length pants that were highly fashionable at the time. Jack in sweater and sneakers looks like a rumpled college kid. Bobby, almost as skinny as Jack, is wearing a pair of Bermuda shorts that appear to be in danger of sliding off his narrow hips.

The sequence of the Kennedys strolling down the street to the park captures the feel of springtime. Georgetown's narrow streets of elegant nineteenth-century townhouses and small gardens punctuated by magnolia trees had made it the residential neighborhood of choice for a "Who's

Who" of the nation's capital. *McCall's* magazine reported that other senators who lived close by sometimes joined in the Kennedys' games.

"As we were coming into the park," Suero remembers, "there were some guys tossing a ball about and one of them whistled at Jackie. She was really very reserved, very shy, and she became upset. She complained to Jack, 'Those guys are whistling at me.' Jack turned to her and said, 'So what do you want me to do, Jackie? Go and beat them up? I can't fight every man in America.'"

There might have been even more pictures in this sequence, Orlando Suero admits ruefully, if Jack Kennedy hadn't urged the photographer to join in the game. "He and Bobby were very competitive," the photographer discovered. "If you got in their way, they'd knock you down. It was definitely a case of 'Playing isn't enough—Winning is everything!' Ethel was really playing, too, but Jackie wasn't joining in. She was too much a lady."

In fact, Jackie had early on opted out of the endless touch football games the Kennedys delighted to play at Hyannis Port. In one of her first games at the family summer home, she had naively asked Ted Sorensen, "When I get the ball, which way do I run?" Jack, in contrast, was some-

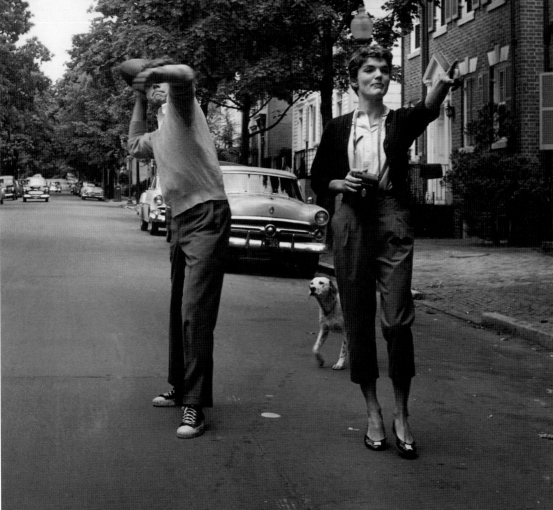

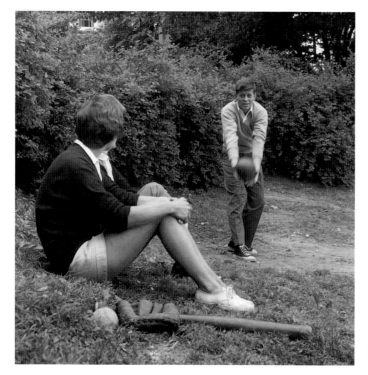 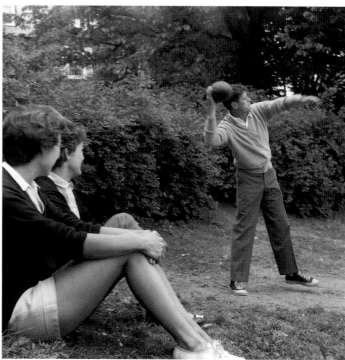

times held to have "majored in football" at Harvard. In spite of his slight build and puny weight, he went all out to win a place on his college's second football squad. When he joined the navy, his first meeting with Red Fay was over a football game. Looking at this skinny young lieutenant, Fay assigned him to the opposing team, then spent the rest of the game dodging the kid's sharp knees and elbows. All his life, football stars were among the people Jack admired most.

Perhaps John F. Kennedy's most courageous attribute was his determination to ignore the almost constant pain he suffered with his chronic back condition. He was able to put up such a good performance for the photographer that Suero admitted: "I had no idea that Jack was in agony with his back. I was absolutely not aware he was in pain. It never showed in anything he did."

If one looks closely, however, the camera clearly reveals that under his sweater Jack was wearing a back brace. The faint outline of the cloth support is

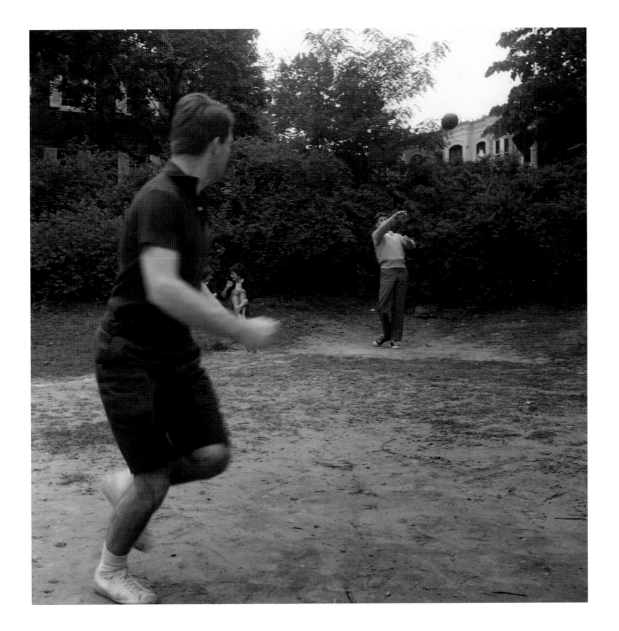

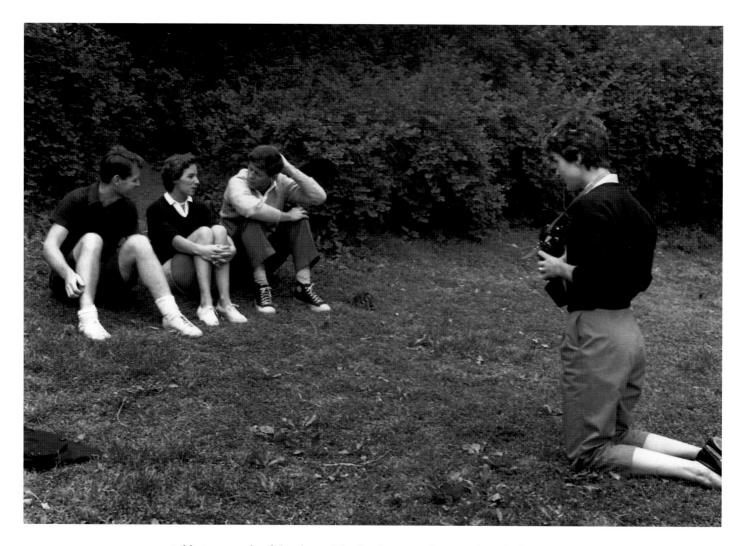

visible in a couple of the shots. Whether he ignored the pain because he was so determined to project a fit, vigorous image in front of Suero's camera, or whether the back pain did not bother him much that day, cannot be known. With all the testimony about his increasingly crippled state that spring, the seeming grace and agility with which Jack trades passes with Bobby in these photographs can only be offered as one of the minor mysteries in the life of John Fitzgerald Kennedy.

When the brothers took a break, Jackie, who, before she married Jack, had been earning her living as the "Inquiring Photographer" for the Washington *Times-Herald*, appropriated Suero's Roloflex camera to take her own photographs of Jack, Bobby, and Ethel. Suero managed to capture her doing so with his spare camera. Because Jackie was taking photographs, too, but Orlando developed the film, we don't know whether some of the photographs in this sequence should carry a credit line "Jacqueline Bouvier Kennedy."

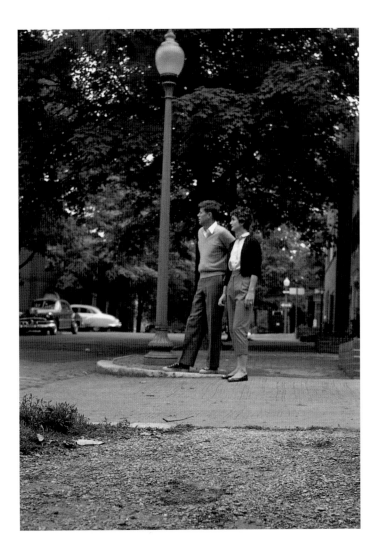

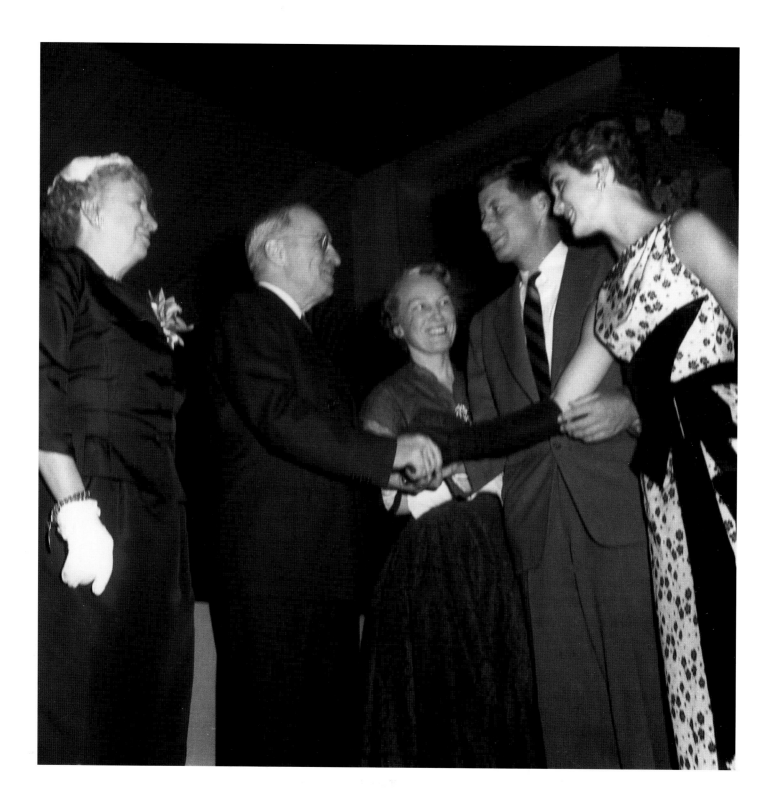

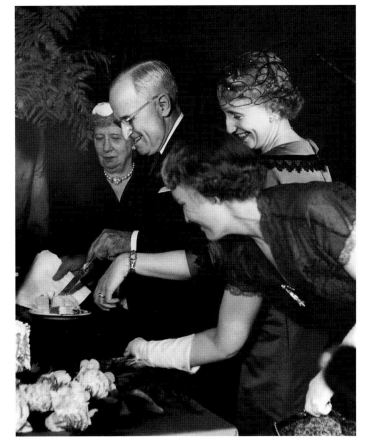

On Friday, May 7, there was an opportunity to capture John and Jacqueline Kennedy together with former president Harry S Truman, his wife Bess, and their daughter Margaret at a birthday reception held as a fund-raiser for the Truman Presidential Library. Truman turned seventy on May 8. JFK introduced Suero to Truman and explained that the photographer's assignment was to focus on Jack and Jackie. "Oh, that's fine," Truman acceded graciously.

Earlier that year, the senator from Massachusetts had become involved with the fund-raising committee for the Truman Library, attending planning lunches on January 23 and March 8, according to Lincoln's office calendar. The ticket price for the May 7 reception was $5 a person, fairly modest even for 1954 prices. The affair raised over $10,000 for the library in ticket sales and other contributions.

During John F. Kennedy's run for president, his father boasted on one occasion that Jack could "draw more people to a fund raising dinner than Cary Grant or Jimmy Stewart," but in 1954 his presence at the Truman reception only merited a passing mention in the social write-up in the *Washington Post and Times-Herald.* Nor did the paper's photographer

bother to get a shot of the former president with the unimportant junior senator.

Held in the Continental Room of the Sheraton Park Hotel, the celebration was attended by many former members of the Truman administration, among them Secretary of State Dean Acheson, who introduced the former president, hoping that he would never get to "that dreary period of life called the years of discretion." Acheson stands in the background as Truman wields the knife to cut his

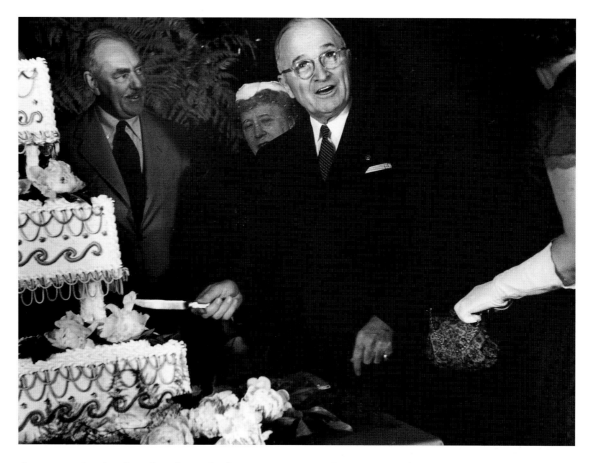

three-tier cake. Another shot shows the former president helping himself to a slice, assisted by his daughter (foreground) and Mrs. Fred W. Morrison (in black net hat), who chaired the affair.

Dean Acheson was a neighbor of the Kennedys in Georgetown and was later to become a foreign affairs consultant to JFK during his presidency. Harry Truman, who always had a little trouble with spelling, a characteristic he shared with Jack Kennedy, could never quite get Dean Acheson's last name right, frequently misspelling it "Atcheson."

When he shook Kennedy's hand at the reception, Truman could not have imagined that the very junior senator from Massachusetts, who so far had not made much of a mark either in the Congress or in the Senate, would, only six years later, become president. At that point Truman had little reason to like the Kennedys. In December 1950, Joseph Kennedy Sr. had delivered a blistering attack on

President Truman's foreign policy in a speech given at a Student Legal Forum at the University of Virginia, where Bobby was then a law student.

True to the isolationist stance that had led him to be recalled as ambassador to Great Britain, Joe Senior had called for the immediate withdrawal of American troops from Korea (America had entered the Korean War in early summer that year) and from Berlin. The former ambassador believed that the American policy of intervention abroad was "suicidal" and "politically and morally bankrupt." He stated that "he would gladly choose a Munich to escape a Dunkirk." Widely reported in the press, the speech infuriated Truman.

In 1960, when Jack was seeking the nomination for the presidency, Truman refused to give him his backing, considering him still too young and inexperienced. Just before the Democratic Convention in Los Angeles, Truman made a statement

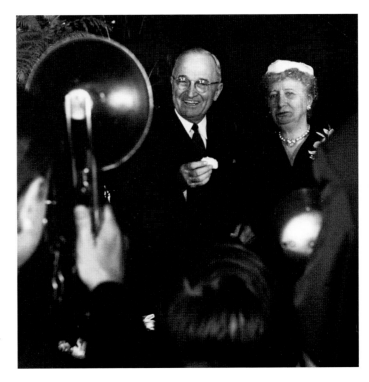

on television that he did not want to support a convention that had been rigged by Kennedy and therefore would not attend. He added that Kennedy "was not presidential timber."

Harry Truman's choice for president was Adlai Stevenson, and it was only after JFK won the nomination at the Los Angeles convention that Truman grudgingly gave him his support. When asked by the press when he decided to back Kennedy, the former president replied tersely: "When the Democratic National Convention decided to nominate him for President. That is all the answer you need."

Once John Fitzgerald Kennedy was elected, the relationship between the two men grew warmer. Before his inauguration, Jack brought Harry home one day to his N Street house on a surprise visit (not appreciated by Jackie, who was in her bathrobe, and could only lean over the stairs to say hello). Truman attended JFK's inauguration, and Kennedy consulted the former president from time to time. In 1961, Harry, Margaret, and Bess Truman and John and Jacqueline Kennedy were all to get together again when Jack invited the Trumans for a weekend at the White House. The Trumans considered a weekend too long for house guests and came just for dinner and a one-night stay.

Although relations were now amicable, the dinner was a culinary disaster. As Margaret Truman related, the White House chef served grouse. The birds were so overcooked that the guests found that their knives could not cut them. Jack looked across the table at Jackie with a mixture of wrath and dismay. It was Bobby who saved the situation by saying, "Those White House knives never could cut butter" and broke everyone up. Truman also helped lighten the atmosphere by playing the White House piano after dinner.

When the Kennedys were pictured with the Trumans in May 1954, Harry and Bess were about to celebrate their thirty-fifth wedding anniversary. No greater contrast could be found between the marriages of the two first couples. Harry Truman had met Bess in Sunday school in Independence, Missouri, when he was six and she was five. From then on, there was no other woman for him. Theirs

was truly a marriage of equals. Truman wrote Bess hundreds of letters, sharing everything with her, including his deepest political concerns. By contrast, at her wedding, Jackie brandished aloft the only missive she had ever received from Jack. It was a postcard from Bermuda with the sole sentiment "Wish you were here!" scrawled across it.

When Suero snapped the former president and the young senator together in May 1954, no one could have predicted that Truman would walk in the younger man's funeral.

There was to be one last strange link between the two presidents. The black horse that walked in John F. Kennedy's funeral procession to Arlington National Cemetery, with boots reversed in the stirrups as a sign of a fallen commander, also walked, nine years later, in Truman's funeral procession in Independence, Missouri.

FBI Director J. Edgar Hoover might describe Bobby as "a dangerous fellow," but Orlando Suero captured a warmer, kinder RFK when he took his camera to Bobby and Ethel's Georgetown home on O Street, where he photographed them with their first three children. The couple had recently moved from S Street into the larger house on O to accommodate their growing family, although at the time there were still more dogs than children in the house.

Ethel married Bobby in June 1950, when she was twenty-two and he was twenty-four. The daughter of a self-made millionaire, George Skakel, who headed the Great Lakes Carbon Corporation, she was fun-loving and athletic. When Bobby graduated in 1951 from the University of Virginia Law School, they moved to Washington, where Bobby got his first job, in the Justice Department. Arthur Schlesinger Jr. wrote that "they lived unpretentiously on S Street, simple in their tastes, unsophisticated in their ways. For a time there was neither alcohol nor even ashtrays in the house." Family friend David Ormsby-Gore, who stayed with Bobby and Ethel at the O Street house for a week in 1955, described their casual style of housekeeping. "No doors were ever shut and everybody wandered

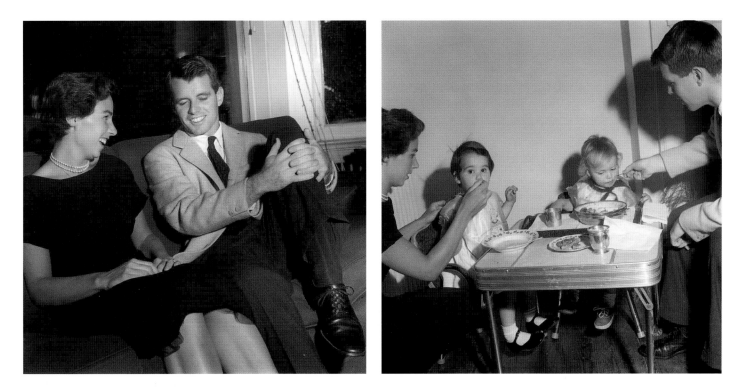

through every room all the time," he related. "It was great fun but it was quite unlike living in any other house I'd ever lived in before."

Jack's spasmodic courtship of Jackie over the early months of 1953 was often conducted at Bobby and Ethel's home. The four of them would have dinner, then go on to a movie together.

As his starting salary at the Justice Department was only $5,334.57 a year, Bobby had insisted that Ethel find a house to rent for a budget of $500 a month, which was quite an adequate allowance for the time. Bobby also tried to set a budget for other household expenses, but Ethel, like Jackie, sometimes had trouble making ends meet. As Red Fay relates, one night over dinner at Hyannis Port, Ambassador Joseph Kennedy berated all his family for their reckless spending, singling out Ethel in particular. She fled the room in tears. When she

reappeared, Jack reassured his sister-in-law. "Ethel, don't worry," Jack joked. "We've come to the conclusion that the only solution is to have Dad work harder."

Like Jackie, Ethel came from a staunchly Republican family and had married into a fiercely Democratic one, but she became totally supportive of Bobby's political career. In April and May 1954, she was leaving the children at home each day to sit in the front row of the public gallery and cheer her husband on in the Army-McCarthy hearings.

Also like her sister-in-law, Ethel had improved her husband's dress code. Bobby had been accustomed to wearing white woolen athletic socks with his suits; Ethel persuaded him that they did not go with business attire.

Bobby and Ethel's first two children were named in memory of Bobby's sister Kathleen and brother

Joe, both of whom died tragically. Their eldest child, Kathleen Hartington Kennedy, was born July 4, 1951, but Bobby insisted she never be called "Kick," the family's name for the older sister who lost her life in a plane crash in 1948. Bobby and Ethel's second child, Joseph Patrick Kennedy III, born in 1952, was named after Bobby's eldest brother, Joseph Kennedy Jr. This brother was killed in the war at age twenty-nine, when on August 12, 1944, he volunteered to pilot a bomber in a special-mission attack on the launching sites of Germany's new "buzz bombs." Joe's plane exploded in midair.

Not until January 17, 1954, when Robert Francis Kennedy Jr. was born, did Bobby have a namesake. Bobby's delight in his children is obvious from Suero's photographs.

The small folding table at which Bobby and Ethel are shown feeding their children got handed down in the family to eldest child Kathleen, who fed her own children from the same table. In the Suero photographs, Kathleen, soon to celebrate a third birthday, takes in everything around her with an intent, wide-eyed gaze. Bobby's first child was to follow in her father's footsteps and opt for a career in politics. Kathleen Kennedy Townsend currently serves as lieutenant governor of the State of Maryland.

Orlando Suero found Bobby "always very friendly, but more reserved than Jack. He played things close to the vest. He also seemed more conservative than his brother. . . . I thought," the photographer adds, "that Ethel was really very sweet."

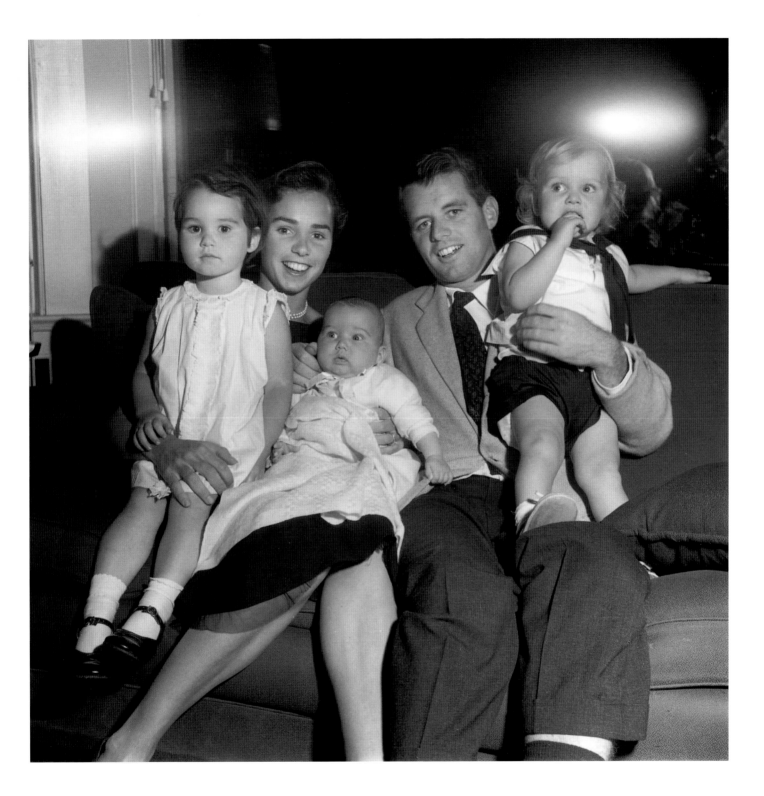

# Postlude

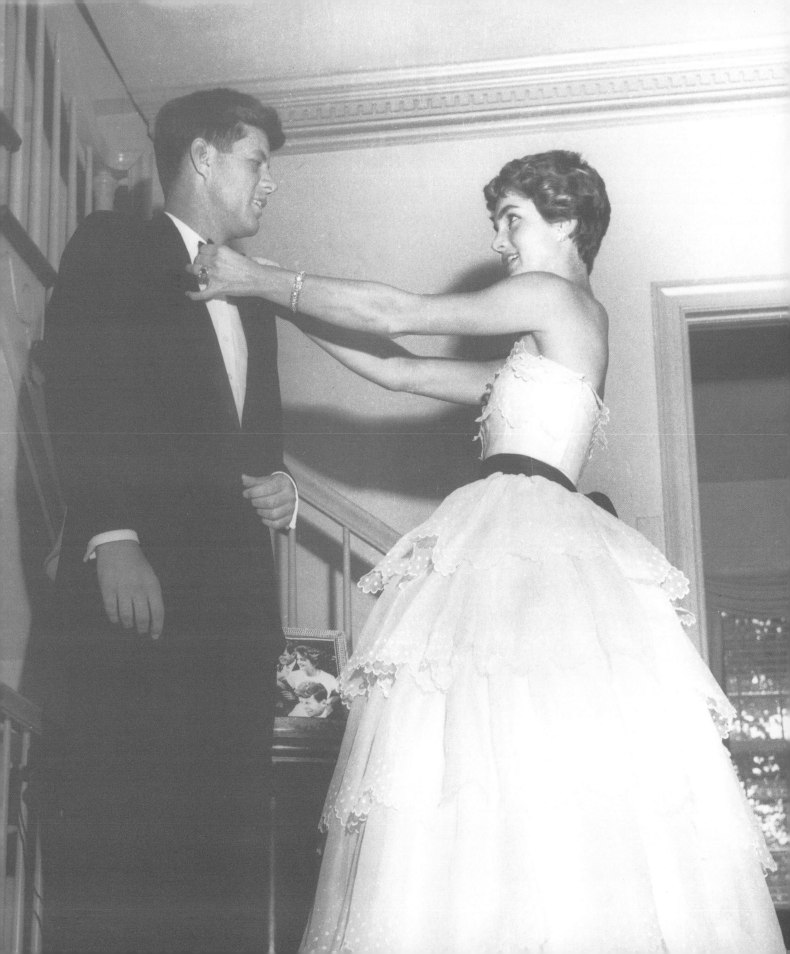

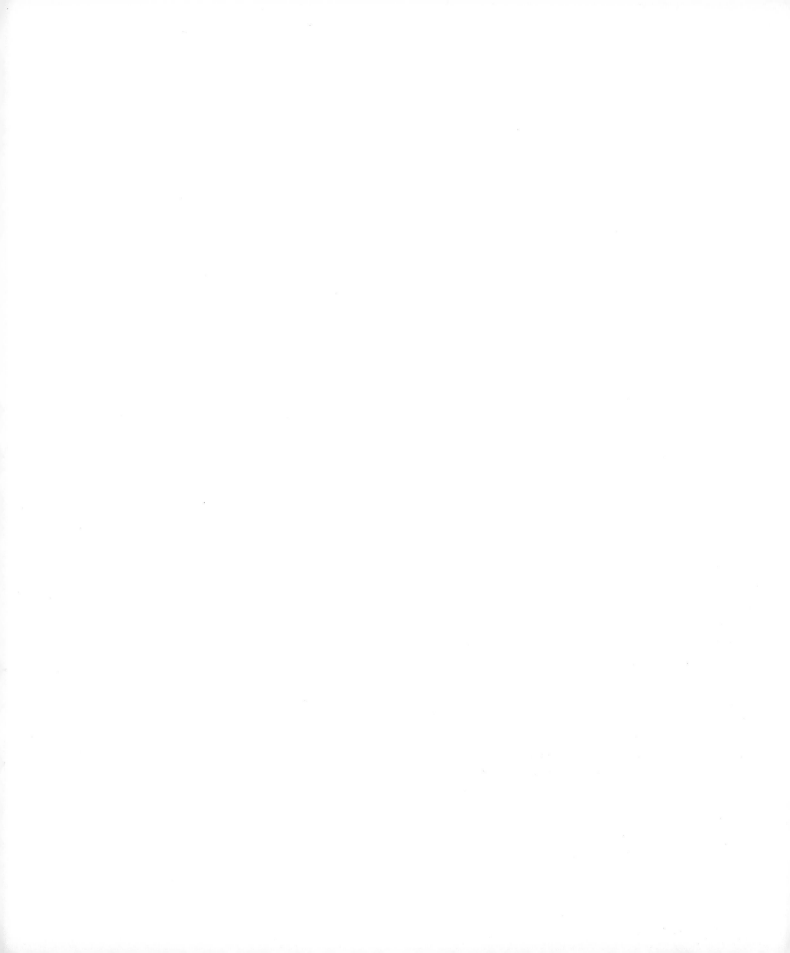

In later years, Suero's path crossed with RFK's twice. A year or so after his 1954 assignment, the photographer had occasion to come back to Washington and ran into Bobby in Garfinkels department store. In those days, Garfinkels always had a few "Men Only" evenings close to Christmas, when, for a couple of hours, the store was closed to women so that men could shop for the women in their lives. Bobby happened to be there choosing a gift for Ethel, and the two men chatted for a few minutes.

In the 1960s, in Los Angeles, Suero undertook the occasional assignment for his former colleagues on the East Coast, particularly for Paul Slade, head photographer of the New York bureau of *Paris Match*. "In June 1968," Orlando recounts, "Paul called me in the middle of the night telling me Robert Kennedy had been shot and would I get over to the hospital. I rushed over to the Good Samaritan Hospital and stood outside on the pavement through the night while Robert Kennedy was dying. I didn't get any photos. I just stood there in shock, remembering playing touch football with him and Jack."

Suero took one photograph that seemed inconsequential at the time. On the morning of May 6, he sat in the back seat of the car as Jackie drove her husband to work and dropped him off at his Senate office. The photographer clicked his shutter as Jack turned to wave goodbye. JFK carried the briefcase that his father had given him in 1938, when Jack had worked briefly as his father's assistant in the U.S. Embassy in London. At the time, Jack was a twenty-one-year-old political science major at Harvard University on summer break. The ambassador had taken his son out on his first day in London to a fancy leather shop on Bond Street and bought him an expensive Hermès briefcase in black alligator skin. Jack cherished it for the rest of his life.

In 1990, when the eighty-year-old Evelyn Lincoln visited the Peabody Archives to help document the Suero photographs, this casual shot of Jack clutching the briefcase brought back emotional memories for her. "Jack was very attached to the briefcase," Mrs. Lincoln related, "because it had been a present from his father and symbolized to a college-age kid being grown-up and intellectual. By the time he became president, the briefcase was falling apart and his aides kept trying to buy him a

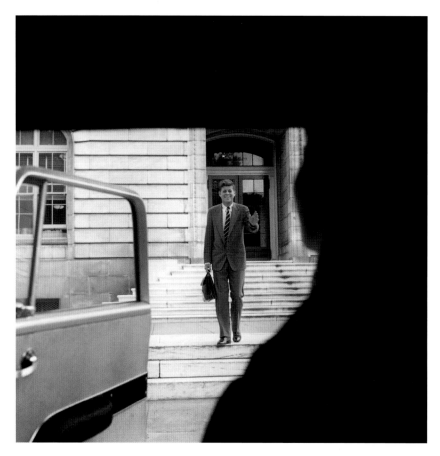

new one. But he wouldn't hear of it. He kept send-
ing me to get it repaired over and over again."

Mrs. Lincoln told us that it was into this patched-
up briefcase, and not the one carried by the Secret
Service men, that JFK would stuff his most secret
papers. His thinking was that if anyone wanted
to make a grab for the top secret papers, they would
obviously go for the briefcase being guarded by the
Secret Service, not for the old battered one being
carried by his secretary.

For the twelve years she worked for him, Mrs.
Lincoln packed the briefcase at the end of each day
with the papers JFK wanted to study overnight,
and she unpacked it each morning. She carried it
everywhere the president went, on trips around
the United States, on *Air Force One* when flying
to Vienna with the president for his meeting with
Khrushchev, and finally on that last motorcade
in Dallas. Evelyn Lincoln was riding several cars

behind the limousine carrying Kennedy. After he
was shot, she followed on to the hospital, where
she learned the president had died. All she could
think to do, she said, was to pick up the briefcase
and clutch it to her.

After the state funeral, Mrs. Lincoln helped the
family clear out the Oval Office. On the final day,
she took the briefcase home with her as a memento
of the man she had served so long. Back in 1963, no
one could have imagined the value that memora-
bilia of the Kennedys would eventually acquire as
the Camelot legend grew. If she had not taken it
home, it is possible that the battered old briefcase
might have been thrown out with the trash.

When Evelyn Lincoln died in 1995 at the age of
eighty-five, it was found that she had bequeathed
the briefcase and other materials to Robert L.
White, a collector of Kennedy memorabilia, who
had dreams of founding a Kennedy museum in
Maryland. Three years later, in 1998, when White
put his collection up for auction, the briefcase
became one of the contested objects in a legal
dispute between White and the John F. Kennedy
Library and former President Kennedy's children.
The sale was to be conducted by Guernsey's Auc-
tion House in New York with a $750,000 reserve
price on the briefcase. John Kennedy and Caroline

Kennedy Schlossberg claimed the briefcase, contending that it had never been legally given to Evelyn Lincoln.

Ultimately, Robert White and the Kennedy family came to an out-of-court settlement by which several items in White's collection, mostly documents, were given to the Kennedy Library. The briefcase was excepted. When bidding in the auction resumed, "Lot 219: The Hermès Briefcase," sold to an anonymous buyer, apparently for $700,000. Its present whereabouts are unknown.

In Evelyn Lincoln's memoirs, *My Twelve Years with John F. Kennedy,* published in 1965, she refers to the briefcase in the very last paragraph of her book. "Everyone remembers his rocking chair," she observes. "But I think of his black briefcase, battered and always full of papers. It is the better symbol for him."

One form of relaxation that Jack and Jackie enjoyed together was listening to popular music. In this photograph Jackie is looking through their shared collection of 78 rpms, which they played on the turntable Victrola of the era. Jackie is holding a particular favorite, a recording of the musical *Brigadoon,* featuring Fred Astaire, which had just opened in New York and was a big hit. She had put this record on at her first dinner party at Dent Place. After a few minutes, the record began to make strange sounds as though the needle had stuck in a groove.

"Jackie, isn't the record player broken?" asked her mother, Janet Auchincloss, who was one of the dinner guests. "Oh no, Mummy," Jackie replied. "It's just Fred Astaire tap dancing."

The record that was to give its name to the Kennedy era was not yet in the Kennedys' collection. The Lerner and Loewe musical *Camelot* did not open on Broadway until 1960, the year JFK became president. The Thanksgiving weekend after the assassination, Jacqueline Kennedy was to tell journalist and family friend Theodore H. White, in an interview for *Life* magazine, that Jack liked to relax at night listening to records: "At night before we'd go to sleep . . . we had an old Victrola. Jack liked to play some records—his back hurt, the floor

was so cold getting out of bed . . . on a Victrola ten years old—and the song he loved most came at the very end of this record, the last side of *Camelot,* sad *Camelot,* 'Don't let it be forgot that once there was a spot, for one brief shining moment that was known as Camelot.'"

This oft-quoted recollection by the distraught widow was to create the myth of Camelot for John F. Kennedy's presidency. As Jackie specifically mentions a "Victrola ten years old," it appears that the one pictured here was in her mind when she was talking with Theodore White. The White House had its own stereo systems, both downstairs, for formal occasions, and upstairs, in the living quarters. Jackie also had a portable player, which she would move from room to room. However, it would appear from Jacqueline Kennedy's own words that the Victrola they had at Dent Place survived all their changes of address and ended up in JFK's bedroom at the White House.

Looking back nearly fifty years later, what Orlando Suero chiefly remembers is that "John Kennedy was one of the most charming men I had ever met. He could disarm you in a moment, with his smile, with his graciousness, with his openness. I mean, forget it! You surrender. You pull up the white flag and say 'I'm yours!'" Suero treasures two letters from Kennedy, which he received a couple of years after his 1954 assignment. The typewritten letters, on the senator's office stationery, are dated June 27 and November 28, 1956, and state that he and Jackie would be pleased for Suero to undertake additional photo assignments photographing them for the Metro Group Photo Agency and *Woman's Home Companion.* In the June 27 letter, Senator Kennedy included Jackie's telephone number at their new home, Hickory Hill in McLean, Virginia, so that Suero could set up the assignment. But it didn't happen. At that time Suero, as he relates today, was too busy pursuing "hard news."

The photographer did go to listen, however, when JFK made a speech in Teaneck, New Jersey, a few years later. "I went to photograph him," Suero recalls, "and John Kennedy saw me in the crowd and he waved to me and called that he wanted to see me later. So afterwards I went back to talk with him, and he asked me where I'd been. We chatted

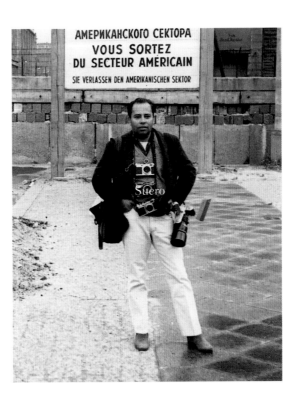

Orlando Suero at Checkpoint Charlie in Berlin during his years as a roving journalist.

for a few minutes. On leaving, he turned and said, 'Hey, don't lose touch. Keep in touch, please!' And, of course, I didn't. And I've lived to regret that. Very much so."

If Orlando Suero had stayed in touch, it is possible that his work might have provided many of the visual images of the White House years.

Jack Kennedy had a lifelong habit of collecting favorite quotations in a notebook. In fact, when he was seeking the presidential nomination in 1959, he used so many quotes that the publishers of *Bartlett's Familiar Quotations* brought out an ad with the message, "Sen. John F. Kennedy owns the modern *Bartlett's*. Do you?"

Just after their honeymoon, Jack had read Jackie a poem he liked by a young American who had been killed fighting for France in the First World War; and she memorized it. In the spring of 1954, as they sat outside in the evening in the back gar-

den at Dent Place, she may have recited it to him. The poem was Alan Seeger's "I Have a Rendezvous with Death."

> *It may be he shall take my hand*
> *And lead me into his dark land*
> *And close my eyes and quench my breath . . .*
>
> *.  .  .  .  .  .  .*
>
> *But I've a rendezvous with Death*
> *At midnight in some flaming town*
> *When spring trips north again this year*
> *And I to my pledged word am true*
> *I shall not fail that rendezvous.*

There are hundreds of books written about the Kennedys. However, John and Jacqueline Kennedy's brief stay at Dent Place from January to June 1954 receives only passing mention in a very few of them, often with jumbled chronology and factual mistakes.

The book that offers the most information about this period in their lives is C. David Heymann's *A Woman Named Jackie,* and I am indebted to this book for several anecdotes.

The only book I have been able to discover that makes reference to the Orlando Suero photo-essay is Jack Parmet's *Jack: The Struggles of John F. Kennedy.* On pages 298 and 299, Parmet refers indirectly to the Suero photographs that appeared in *McCall's* magazine; he claims they "were designed for Sunday roto-gravure sections." One or two of the Suero photographs did eventually trickle into a few Sunday newspapers, mainly in the Boston area. The majority of picture editors, however, decided that the Kennedys had been "overexposed" by the massive publicity on their wedding and declined the opportunity to run the Suero pictures. Parmet notes that the photographs "made a special effort to portray [the Kennedys] as a modest, hardworking, and romantic collegiate couple." He relates that "in those early postwar years, when veterans commonly combined the responsibility of raising their own young families with completing advanced education under the GI Bill, the media portrayed the Kennedys in similar circumstances."

General background information has come from standard books on the Kennedys: the adulatory books first published by their contemporaries; subsequent "investigative" tomes; and finally, with the release of so much new material in the past decade, studies that attempt to present more balanced portraits. Listed below are materials that proved especially helpful for the purpose of this book.

Anderson, Christopher. *Jack and Jackie: Portrait of an American Marriage.* New York: William Morrow, 1996.

Bradlee, Benjamin C. *Conversations with Kennedy.* New York: W. W. Norton, 1975.

Fay, Paul B. ("Red"). *The Pleasure of His Company.* New York: Harper & Row, 1966.

Gallagher, Mary Barelli. *My Life with Jacqueline Kennedy.* New York: David McKay, 1969.

Hamilton, Nigel. *JFK: Reckless Youth.* New York: Random House, 1992.

Hersh, Seymour M. *The Dark Side of Camelot.* Boston: Little, Brown, 1997.

Heymann, C. David. *RFK: A Candid Biography of Robert F. Kennedy.* New York: Dutton, 1998.

———. *A Woman Named Jackie.* New York: Lyle Stuart, 1989; reprint, New York: Signet, 1990. Page references to Signet edition.

Kennedy, Rose Fitzgerald. *Times to Remember.* New York: Doubleday, 1974.

Kennedy Family and Friends. *John Fitzgerald Kennedy As We Remember Him.* New York: Atheneum/Columbia Records Legacy Collection Book, 1965.

Klein, Edward. *All Too Human: The Love Story of Jack and Jackie Kennedy.* New York: Pocket Books, 1996.

Lasky, Victor. *J.F.K.: The Man and the Myth.* New York: Macmillan, 1963.

Leamer, Laurence. *The Kennedy Women: The Saga of an American Family.* New York: Villard Books, 1994.

Lincoln, Evelyn. *My Twelve Years with John F. Kennedy.* New York: David McKay, 1965; reprint, New York: Bantam Books, 1966. Page references to the Bantam edition.

Mahoney, Richard D. *Sons and Brothers: The Days of Jack and Bobby Kennedy.* New York: Arcade, 1999.

Manchester, William. *One Brief Shining Moment: Remembering Kennedy.* Boston: Little, Brown & Co., 1983.

Martin, Ralph G. *A Hero for Our Time: An Intimate Story of the Kennedy Years.* New York: Macmillan, 1983.

McCullough, David. *Truman.* New York: Simon & Schuster, 1992.

McTaggart, Lynne. *Kathleen Kennedy: Her Life and Times.* New York: Holt, Rinehart & Winston, 1983.

O'Donnell, Kenneth, and David Powers, with Joe McCarthy. *"Johnny, We Hardly Knew Ye": Memories of John Fitzgerald Kennedy,* Boston: Little, Brown & Co., 1970.

Oppenheimer, Jerry. *The Other Mrs. Kennedy— Ethel Skakel Kennedy: An American Drama of Power, Privilege, and Politics.* New York: St. Martin's Press, 1994.

Parmet, Jack. *Jack: The Struggles of John F. Kennedy.* New York: Dial Press, 1980.

Reeves, Thomas. *A Question of Character: A Life of John F. Kennedy.* New York: Free Press, Macmillan, 1991.

Schlesinger, Arthur M., Jr. *Robert Kennedy and His Times.* Boston: Houghton Mifflin, 1978.

———. *A Thousand Days: John F. Kennedy in the White House.* Boston: Houghton Mifflin, 1965.

Sidey, Hugh. *John F. Kennedy, President.* New York: Atheneum, 1964.

Sorensen, Theodore C. *Kennedy.* New York: Harper & Row, 1965.

Truman, Margaret. *Harry S Truman.* New York: William Morrow, 1973.

*McCall's,* October 1954.

*Washington Post and Times-Herald* (the two newspapers were amalgamated at the time) for the first two weeks of May 1954. This newspaper provides detailed coverage of the Army-McCarthy Hearings, the events leading up to the fall of Dien Bien Phu, the birthday reception for Harry Truman, and the listing for JFK's interview on *Man of the Week.*

Evelyn Lincoln's Office Calendar for the first two

weeks of May 1954, kindly made available by the John F. Kennedy Library (JFKL) in Boston.

## Prelude

### The Newlyweds and the Photographer (pages 5–8)

General source for this section: Evelyn Lincoln, conversation with the author, December 1990.

Bobby's quip about a mosquito biting Jack: RFK used his widely quoted childhood joke in his own tribute to JFK in the family's memorial, *John Fitzgerald Kennedy As We Remember Him,* VI.

### Evelyn Lincoln's Calendar (pages 9–11)

Mass in memory of Kathleen Kennedy Hartington: For the fullest account of her life, see McTaggart, *Kathleen Kennedy.*

### The House at Dent Place (pages 12–15)

The condition of the house and its contents: Copies of the lease and correspondence on claims for damages, provided by the family of Blair and Virginia Childs—their son Blair Childs Jr. and their three grandchildren, S. Terry Childs, Blair G. Childs, and Christopher A. Childs.

Torby McDonald on JFK's untidiness: Hamilton, *JFK,* 241.

Jackie's obsessive redecorating: Gallagher, *My Life with Jacqueline Kennedy.*

Jack and Jackie's moving from house to house: Elisabeth Draper, quoted by Heymann in *Woman Named Jackie,* 198.

JFK picking up papers and borrowing money for Mass: Fay, *Pleasure of His Company,* 98. JFK told Fay that his Republican neighbors would say "How can he run the country?" if he left the N Street house in a mess.

### Building Rapport with the Camera (pages 16–17)

General source for this section: Orlando Suero, interviews with author.

## May 5 to 9, 1954

### The Two Brothers (pages 23–25)

Having a few close friends in for dinner: Sorensen, in *Kennedy,* wrote: "They lived in a fashionable but unpretentious house and avoided the Washington cocktail circuit to an unusual degree. Both strongly preferred small groups of friends to large crowds" (20).

Details of RFK's favorite dogs: Courtesy of Allan B. Goodrich, curator at JFKL.

The close relationship between JFK and RFK: Schlesinger, *Robert Kennedy and His Times;* Heymann, *RFK;* and Mahoney, *Sons and Brothers.*

Jackie's Sevrès china: Letitia Baldridge, White House social secretary, quoted by Anderson, *Jack and Jackie,* 135.

Guests finding half-eaten hamburgers: Leamer, *Kennedy Women,* 394, quoting Joseph Alsop's Oral History at JFKL.

Army-McCarthy Hearings: The hearings were covered daily in the *Washington Post and Times-Herald* for April and May 1954. Also see Schlesinger, *Robert Kennedy and His Times,* 112–15.

### A Wedding to Remember (page 27)

General source for this section: Orlando Suero, interviews with author.

### The Junior Senator from Massachusetts (pages 30–37)

General source for this section: Orlando Suero, interviews with author.

Jack's speeches and activities as a senator, and his casual dress: Sorensen, *Kennedy*. Also, Lincoln reports in *My Twelve Years* that "when the Senator first came to Washington as a Congressman, he brought only one suit and two shirts" (14).

Ted Reardon's dismay at JFK's color combination: Quoted by Heymann in *Woman Named Jackie*, 166; and in Manchester, *One Brief Shining Moment*, 36.

Jackie's joining Ladies of the Senate Red Cross: Heymann, *Woman Named Jackie*, 166, 167.

Jack's visit to French Indochina: Mahoney, *Sons and Brothers*, 12.

Jackie's role as senator's wife: *McCall's*, October 1954.

"Politics kept her husband away too much": Sorensen, *Kennedy*, 37.

JFK's attending wakes: O'Donnell and Powers, *"Johnny, We Hardly Knew Ye,"* 59.

Refusing to be photographed with glasses; Jackie's delivering meals: Sorensen, *Kennedy*, 41.

Jackie's book for Janet Auchincloss: Anderson, *Jack and Jackie*, 131.

JFK's health problems: Lincoln, *My Twelve Years*, 43–46.

### Lem Billings (pages 37–39)

General source for this section: Orlando Suero, interviews with author.

JFK's determination to keep old friends: Sidey, in *John F. Kennedy, President*, quotes JFK: "The Presidency is not a very good place to make new friends. I'm going to keep my old friends" (36).

Relationship with Billings; JFK's letters to Billings: Hamilton, *JFK*, 111–14.

### Man of the Week (pages 39–40)

Program listing: *Washington Post and Times-Herald Weekly Radio Guide*, second week of May 1954.

Main newscasts only 15 minutes: Manchester, *One Brief Shining Moment*: "On September 12, 1963, CBS increased its nightly CBS Evening News from 15 to 30 minutes and NBC followed suit a week later" (14).

"Young Lochinvar": James Reston, *New York Times*, November 4, 1960.

JFK's relationship with the press: Bradlee, *Conversations with Kennedy*; Lasky, *J.F.K.*

### Off to a Dance (page 41)

General source for this section: Orlando Suero, interviews with author.

### A Student at Georgetown University (pages 44–48)

General sources for this section: Orlando Suero, interviews with author; *McCall's*, October 1954.

Jules Davids's contribution to *Profiles in Courage*: A full discussion is found in an article by Nancy Freiburg in *Georgetown University Magazine*, fall 1997.

Ambassador Joe Kennedy's promotion of *Why England Slept*: Reeves, *Question of Character*, 50.

Ambassador Joe Kennedy's "book that really makes the grade with high-class people" occurs in his April 1940 letter to Jack, quoted by Rose Kennedy in *Times to Remember*, 225.

Eating Good Humor ice cream: Jacqueline Kennedy to Orlando Suero, October 1954.

### Portrait of Jackie with a Flower (page 49)

General source for this section: Orlando Suero, interviews with author.

"The only pictures . . . where I don't look like something out of a horror movie": Jacqueline Kennedy to Orlando Suero, October 1954.

### Painting in the Garden (pages 53–54)

General source for this section: Orlando Suero, interviews with author.

Kennedys descending upon painting set: Lem Billings, quoted by Heymann in *Woman Named Jackie,* 134.

Painting in Palm Beach: Evelyn Lincoln, conversation with author, 1991; Lincoln, in *My Twelve Years,* says that JFK "thought his paintings didn't look too bad, although some said all he did was to paint rows and rows of houses" (39).

Rose Kennedy's dismay at Jack painting: Heymann, *Woman Named Jackie,* 171.

Note: Martin, in *A Hero for Our Time,* 98–100, claims that the painting set was a present from Jack to Jackie but that Jack appropriated it for his use. Martin quotes Jacqueline Kennedy as claiming the gift to have been intended for her, a version that is contradicted by Lem Billings and Evelyn Lincoln. Possibly Jackie "revised" the story or Martin misquoted her.

### The Speed Reader (page 62–63)

Description of course: *Johns Hopkins University Evening College Catalog,* 1954.

JFK's enrolling in speed-reading course: Sorensen, *Kennedy,* 23.

JFK's giving up class due to back pain: Lincoln, *My Twelve Years,* 43–46.

JFK horrified at gardener's bill: Lincoln, conversation with author.

### Fond Memories from Mattie Penn (pages 63–66)

Mattie Penn and the Childs family: Childs family, conversations with the author; copies of letters between White House and Mattie Penn made available to the author by Christopher Childs.

Jack bringing forty guests for lunch: Anderson, *Jack and Jackie,* 134.

Jackie's account of her disaster cooking dinner: Heymann, *Woman Named Jackie,* 166.

JFK's attributing his weight loss to Jackie's cooking: Evelyn Lincoln, conversation with the author.

Stuffed fish tale: Lincoln, *My Twelve Years,* 40.

### Lighting the Candles (pages 67–68)

General source for this section: Orlando Suero, interviews with author.

Jack's calling Jackie *fey*: JFK interview with Laura Bergquist for article "Jacqueline: What You Don't Know about Our First Lady," *Look,* July 4, 1961.

"There was something . . . luminous about Jack": Leamer, *Kennedy Women,* 538, quoting Bartlett interview with Laura Bergquist for *Look* magazine.

### Tossing a Football Around (pages 70–74)

General source for this section: Orlando Suero, interviews with author.

Other senators sometimes joined in the Kennedys' games: *McCall's,* October 1954.

Jackie asking which way to run: Sorensen, *Kennedy,* 37; also see 38–40 for discussion of JFK's back problems.

The skinny young lieutenant in a football game: Fay, *Pleasure of His Company,* 135–36.

JFK becoming increasingly crippled: Lincoln, *My Twelve Years,* 43–47.

### Celebrating Harry Truman's Seventieth Birthday (pages 77–80)

Details of Dean Acheson's speech of welcome, ticket price, and notables present: *Washington Post and Times-Herald,* May 8, 1954.

Joe Kennedy Sr. on JFK's fund-raising power: Hersh, *Dark Side of Camelot,* 89, quoting Ed Plaut's 1959 interview with Joe Senior.

Joe Kennedy's isolationist speech at University of Virginia: Schlesinger, *Robert Kennedy and His Times,* 84.

Truman's refusal to support Kennedy's nomination: McCullough, *Truman,* 970–74.

Trumans at the White House in 1961, overcooked grouse: Truman, *Harry S Truman,* 574.

Postcard from Bermuda: Manchester, *One Brief Shining Moment,* 63.

Black horse in Truman's funeral: McCullough, *Truman,* 988.

### At Bobby and Ethel's Home (pages 80–82)

General source for this section: Orlando Suero, interviews with author.

"They lived unpretentiously on S Street"; Ormsby-Gore quotation: Schlesinger, *Robert F. Kennedy and His Times,* 118. Ormsby-Gore, later Lord Harlech, became British ambassador to Washington during the Kennedy presidency.

Bobby's salary and rent allowance to Ethel: Oppenheimer, *Other Mrs. Kennedy,* 158.

"Ethel, don't worry . . . have Dad work harder": Fay, *Pleasure of His Company,* 11. (Ethel is named in the unedited manuscript of the book at JFKL.)

White woolen athletic socks: Schlesinger, *Robert F. Kennedy and His Times,* 101.

## Postlude

### Last Encounters (page 89)
### A Cherished Briefcase (pages 89–91)

General source for these sections: Evelyn Lincoln, conversation with the author, December 1990.

Account of Robert L. White auction of briefcase: *Baltimore Sun* articles by Jean Marbella, March 15, 19, 1998.

### The Old Victrola (pages 91–92)

Jackie's mother's asking if record player is broken: Leamer, *Kennedy Women,* 436.

Listening to *Camelot* on old Victrola: Theodore H. White, interview with Jacqueline Kennedy one week after the assassination, *Life's Memorial Issue,* December 1963. This quote is often abbreviated, but the full transcript reveals that the Victrola was ten years old.

### Rendezvous (pages 93–94)

General source for this section: Orlando Suero, interviews with author.

JFK's preoccupation with death: Frequently mentioned in books about him. See Schlesinger, *A Thousand Days,* 96; Parmet, *Jack,* 190.

E842.1
.S84
2001